P9-CCX-257

Praise for *The Dangerous Book for Boys*

"Offers a portal back to a time of 'Sunday afternoons and long summer days' . . . suggests activities with a whiff of rebelliousness without advocating anything truly unsafe . . . Refreshingly free of brands or logos."
—*Newsweek*

"A delightful collection of old-fashioned mischief."
—*The New York Post*

"It's no use trying to shield your offspring from the disastrous influence of popular culture . . . Better to set that influence next to something it has no hope of competing with: the excitement and pride of knowing semaphore or ciphers or Robert Scott or bugs or fossils."
—*The New York Sun*

"A sepia-toned celebration of the lost arts of childhood, complete with information on how to make a treehouse, fold paper airplanes, and skip stones."
—*The New York Times*

"A zestfully nostalgic celebration of boyhood past . . . [the book] has many of the timeless qualities of an ideal young man: curiosity, bravery, and respectfulness; just enough rogue to leaven the stoic . . . Rudyard Kipling would have loved it."
—*Time*

"A testosterone-fueled throwback of a field guide."
—*Vanity Fair*

THE POCKET DANGEROUS BOOK FOR BOYS:
THINGS TO DO

Many of the pieces in this edition have been selected from the much loved *The Dangerous Book for Boys*. They have been chosen to give readers things to do, inside and out, during the long summer days.

This edition is a perfect pocket format for readers to take everywhere with them. It has new drawings and new activities.

Also by Conn and Hal Iggulden:

The Dangerous Book for Boys

Also by Conn Iggulden:

The Emperor series
The Gates of Rome
The Death of Kings
The Field of Swords
The Gods of War

The Conqueror series
Wolf of the Plains

Blackwater

The Pocket
DANGEROUS
Book for Boys

THINGS TO DO

Conn Iggulden & Hal Iggulden

Collins
An Imprint of HarperCollinsPublishers

NOTE TO PARENTS: This book contains a number of activities which may be dangerous if not done exactly as directed or which may be inappropriate for young children. All of these activities should be carried out under adult supervision only. The authors and publishers expressly disclaim liability for any injury or damages that result from engaging in the activities contained in this book.

An edition was published in the U.K. by HarperCollins Publishers in 2007.

Copyright © 2008 by Conn Iggulden and Hal Iggulden. All rights reserved. Printed in The United States of America. No part of this book may be used or reproduced in any manner whatsoever without written permission except in the case of brief quotations embodied in critical articles and reviews. For information, address HarperCollins Publishers, 10 East 53rd Street, New York, NY 10022. HarperCollins books may be purchased for educational, business, or sales promotional use. For information, please write: Special Markets Department.

First U.S. Edition

Library of Congress Cataloging-in-Publication Data has been applied for.
ISBN 978-0-06-165682-8

Copyright © Conn Iggulden and Hal Iggulden 2006, except the following chapters which are Copyright © Conn Iggulden and Hal Iggulden 2007: "Introduction," "Games," "Bottle Rocket," "Making Candles," "Making a Quill Pen," "Papier-maché," "Two Quick Things To Do."

Illustrations on pages 1, 11, 13, 15, 17, 18, 58, 60, 62, 64, 66, 67, 74, 75, 76, 78, 79, 81, 82, 83, 90, 91, 92, 93, 94, 122, 123, 124, 147, 148, 149, 157, 159, 160, 161 © HarperCollins*Publishers* 2007, created by Andrew Ashton.

Illustrations on pages 174, 175, 176, 177 © Andrew Ashton 2007.

Illustrations on pages 24, 26, 28, 29, 31, 33, 35, 36, 37, 41, 44, 45, 46, 47, 49, 50, 52, 54, 56, 69, 70, 86, 87, 88, 89, 102, 103, 107, 109, 110, 114, 115, 117, 130, 133, 134, 135, 136, 138, 142, 143, 167, 170 © Jay Gosney 2007.

Illustrations on pages 97–99: Brook Trout, Pike, Smallmouth bass, and Walleye courtesy of U.S. Fish & Wildlife Services. Minnow © *Collins Gem Fish.*

08 09 10 11 12 WBC/RRD 10 9 8 7 6 5 4 3 2 1

To all of those people who said "You have to include . . ." until we had to avoid telling anyone else about the book for fear of the extra chapters. Particular thanks to Bernard Cornwell, whose advice helped us through a difficult time, and Paul D'Urso, a good father and a good friend.

CONTENTS

.

INTRODUCTION

———✦———

THERE'S SOMETHING MAGICAL about small books. Somehow you *own* them more than large ones. You can keep them in a secret box, or the crook of a tree. You can fit them into a coat pocket, or a backpack. The original *Dangerous Book for Boys* couldn't have been made any smaller; we wanted to fit everything into it. The only problem was that it wasn't very portable, which is a shame when you want it to be taken outside every now and then. What we've done here is conjured two pocket versions out of the book: *Things to Do* and *Things to Know.*[*] We've added extra chapters too—you're going to love the Bottle Rocket—but if you're holding this, you'll know it's just the right size to take with you on adventures. The only thing we couldn't do was make it fireproof and waterproof, but who knows? Maybe we will, yet.

Conn Iggulden and Hal Iggulden

[*] Coming later

GAMES

MOST GROUP GAMES involve a large number of children, like Murder in the Dark, Tug of War, and Capture the Flag. You'll play them at parties, or at Boy Scouts.

These games are the sort you can play with the family in a car, or at home. We haven't included charades, because everyone knows it already. We also haven't included I Spy, because it's the dullest game on earth. With any luck, you don't know all of these and you'll find a few worth trying.

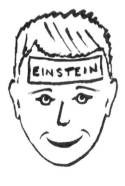

Who Am I?

You'll need Post-It notes for this. One person writes a name on the sticky paper, then puts it on the next person's forehead so that everyone else can read the name. That person then asks questions like "Am I a man?" and "Am I dead?" until they guess who they are. Only "yes" or "no" questions are allowed. It doesn't sound like fun, but it is.

One of the authors had the odd experience of seeing someone with "Genghis Khan" on her forehead. With desperate hints, she got as far as "He was a Mongol leader who lived eight centuries ago— second name 'Khan.'" She didn't get it, so it doesn't always work. Pick names that have some chance of success.

Memory Games

These involve a lengthening list that always starts with the same phrase. For example: "I went to the party and I brought apples." The next person then has to come up with something beginning with "b": "I went to the party and I brought apples and books." You continue down the alphabet, seeing how long you can keep it going. "I went to the party and I brought apples, books, a cat, dinosaurs, an elephant, foxes, goats, hats, ink . . ."

Handshake Puzzle

This next one is just a simple mental puzzle, but it's fun to work out.

Question: If there are two people in a room and each one shakes hands once with every other person in the room, how many handshakes are there?

Answer: One handshake.

Not too hard.

Question: If there are three people in a room and everyone shakes hands only once with everyone else, how many handshakes are there?

Answer: Three handshakes.

Now, how many handshakes will there be for *five* people in the room, with everyone shaking hands once with everyone else? (See the end of the chapter for the answer.)

Cheat

This is one for the home rather than the car. You need four people and a pack of cards.

Deal out all the cards. Each player then arranges them so that multiples of numbers or picture cards are together, like three sevens, or three kings. The aim of the game is to get rid of all your cards without someone calling "Cheat!"

Clockwise from the dealer, each player takes his turn in laying cards face down, so that no one else can see them. At the same time, he says what they are. He might lay down three cards and say "Three eights," for example.

The next player can now lay down only eights, nines, or sevens—the same card or one up or down. If he doesn't have a card with the right number, he can risk cheating by laying down just one card, saying the number, and keeping a very straight face.

Obvious cheating is when you are sitting there with three nines and someone lays two cards, saying "Two nines" with great confidence. There are only four of each number, so you call "Cheat!"

At that point, they turn over the cards. If they have been caught cheating, they have to pick up the whole

pile—and they usually discover all the other cheating that's been going on.

As the game is called Cheat, you can try putting three cards down while only declaring two. If no one notices, that's fine. As the game goes on, you have a good idea what other people have in their hands, so you can force them to cheat and pick up the pile.

With the exception of poker, this is one of the best card games we've ever played.

Beggar-My-Neighbor

A card game for two players. Deal out all the cards, so you have one half of the deck each. In turns, lay down one card at a time, face up. If an ace appears, the other player must put four cards on top of it. For a king, it's three. For a queen, it's two, and just one for a jack. If another jack, queen, king, or ace appears as the penalty cards are laid down, it becomes the first player's turn to add more. If it doesn't, the player must pick up the pile. The aim of the game is to win all of your opponent's cards.

Crossing the River

This is a classic mental puzzle that you can do in your head.

A farmer is on the side of a river with a fox, a hen, and a sack of grain. His boat will only carry him and one other item. He needs to get them all across the river, but he cannot leave the fox with the hen, or the hen will be eaten. He also cannot leave the hen with the grain, or that will be eaten. How does he get all three across the river?

(Answer at the end of the chapter.)

Questions

Simple and fun. One person begins with a question such as "Is your name David?" and the next must reply with another question: "Why would you say that?" for instance. This goes on until someone hesitates or misses a question.

Hesitation/Deviation or Repetition

You'll need a stopwatch for this. The aim is to keep talking on a random subject for a minute without hesitation—a long pause, deviation—going off the subject, or repetition—saying the same word twice. If you are successfully interrupted for one of these points (a buzzer noise is always good) your opponent wins one point. The stopwatch is paused and he takes over the subject. Start the clock on him. The person talking at the end of the minute also wins a point. (Keep careful score, interruptions can happen a lot.)

The Yes/No Game

Again, you'll need a watch to time this. One person asks questions and the other has to avoid saying either "yes" or "no" or hesitating. He also cannot shake or nod his head.

For example:
Is it raining? It is.
Are you sure? I am.
Do you like the rain? I do
You do? Yes.

It is surprisingly hard to resist saying yes or no.

Word Association

One player says a word and the next has to reply with the first word that pops into his head—as fast as possible.

Blow Football

Definitely not one for the car, as you need a table, two straws, a Ping-Pong ball, and either four boxes of matches or four books to make the goals.

Begin with the ball in the middle, then both players try to blow it into the opponent's goal.

Penny-up-the-Wall

A real old favorite, this one is for two or more players. Standing a set distance from a wall, each player takes the same kind of coin—and tosses or rolls it toward the wall. The closest throw wins all the coins.

Fast Draw

You will need enough family and friends to make teams, large sheets of paper, pens, and a timer. One person thinks of a film title and then draws a picture of it. The other members of the team try to guess it in less than sixty seconds.

Board Games

It's a good idea to get the classic family board games as well. No home is complete without Chutes and Ladders, Monopoly, Clue, Ludo, Scrabble, Trivial Pursuit, and Risk.

Answers

Handshake Puzzle: Ten handshakes. For six people, it's fifteen; for seven, twenty-one.

Crossing the River Puzzle: First the farmer takes the hen across, leaving the fox and the grain. Leaving the hen on the far bank, he returns and takes the fox across. On his second return journey, he takes the hen with him, leaving the fox on the far bank. He puts the hen down and takes the grain across, so that it sits once more with the fox, then finally, he returns a third time and once again takes the hen across. There are a number of other ways to solve the puzzle.

SKIPPING STONES

THIS IS QUITE A TRICKY skill, but it is possible to bounce a stone on water five or six times without too much trouble. Englishman Barnes Wallis used the same principle when designing the bouncing bomb for raids on the Ruhr Valley in Germany in World War II. You will need several things in your favor to skim like the Dambusters.

First of all you need to pick your stone, as flat as possible without being too thin. It needs some weight to travel, but if it weighs much more than an apple, you won't get the range. Most beaches will have a variety of stones to choose from, but if you find the perfect "skipper" in the park, hang on to it.

Skipping on the sea is harder because of the waves. If you try it on a lake, watch out for swimmers, who object to having stones thrown at them.

The skill is in the grip and the angle. Curl your index finger around the stone, resting it on your middle finger. Secure it with your thumb.

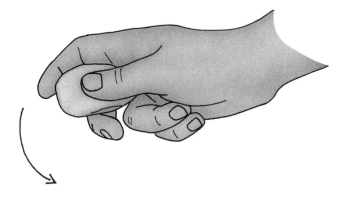

The action of throwing the stone is all-important—too steep and the stone will just plonk into the water. Bend your knees to keep the angle of descent around 25° and try to get the flat side to hit the water when you release, to help it bounce on the surface.

The power you use to throw the stone can be increased once you get the hang of it.

More than one bounce and you are "skipping," though you will have a way to go to beat the current world record of *thirty-eight*.

MAKING A PAPER HAT

THERE IS SOMETHING ridiculously simple about this, but how to make a paper hat is something every boy should know. After all, with a little luck, you may one day have children of your own.

1. Fold a sheet of letter-sized paper in half, as shown.

2. Fold a central line in the half-page and open out again.

3. Turn down the corners to that central line.

4. Fold one long strip up.

5. Fold up the other edge and you now have a paper hat—open it. This also works well with newspaper, but plain paper can be painted or colored.

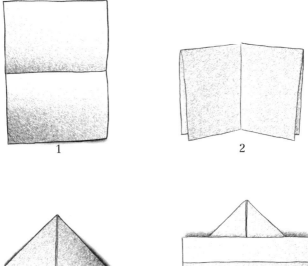

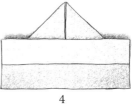

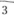

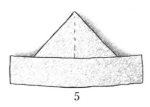

MAKING A PAPER HAT

13

COIN TRICKS

COIN TRICKS ARE EASY to do and very effective. Here we will show you some simple sleight-of-hand "vanishes."

Any coin will do, the bigger the better, though I would suggest nothing smaller than a quarter.

Most tricks are over quite quickly, but a little "patter" (spoken introduction) is still required. The speed of the trick is not important. It's all about the smoothness of movement, and that takes practice. Misdirection and the final flourish will make you seem like a seasoned magician. When performing, let your hands move smoothly and confidently.

One of the oldest coin sleights is called "the French Drop," a simple, effective "vanish." The reappearance is also important and we will suggest some examples such as taking it from behind a spectator's ear, but with a little ingenuity and practice you will come up with some ideas of your own to keep the spectators captivated.

The French Drop

If you are right-handed, hold the coin by its edge in your left hand between your first two fingers and your thumb, making sure the hand is turned palm up and the fingers are curled in.

With the right hand palm down, go to grab the coin, with the thumb of the right hand going underneath the coin and the fingers above it. Close the right hand into a fist to take the coin.

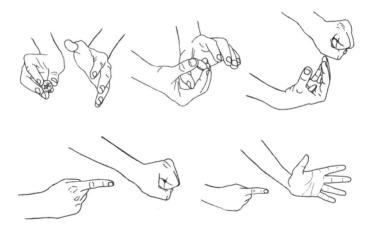

At this point, release the coin, letting it fall into the cupped fingers of the left hand. The right hand now moves forward, supposedly holding the coin. The left hand drops to your side with the real coin.

This sleight is quite elegant and needs to be performed smoothly and naturally. A good way to practice is to alternate between the French Drop and actually taking the coin, so when you perform the sleight you duplicate precisely the action of taking the coin.

Check occasionally in the mirror to see if it looks natural. Do not try to hide the coin in your left hand, just let the hand drop to your side. You could point to the right hand with a left finger, to misdirect the attention of the spectators. Always keep your eyes on the right hand, and then drop the left hand to your side.

Everyone watching will think the coin is in the right hand, so hold it out straight, focus on it, and open the hand finger by finger. It will have vanished! Now reach toward a spectator with your cupped left hand and produce the coin from behind his ear! They can't see the approach around the back, so this is fairly easy.

THE EASY VANISH

The Easy Vanish is simple to perform yet very deceptive. Hold both hands palms up with a coin on the second and third fingertips of the right hand. Hold the coin in place with the right thumb.

Now turn that hand over and slap the coin into the palm of the left hand. Close the fingers of the left hand over the fingers of the right; withdraw the right hand, but hang onto the coin, using your thumb. Drop your right hand down by your side and reveal an empty left hand!

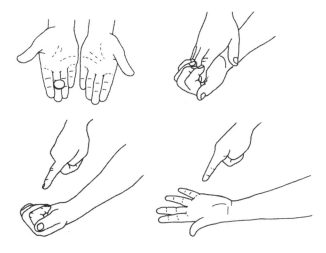

The Basic Vanish

Hold both hands out, palms up, with a coin in the center of the right hand. The right hand approaches the left hand from below, so the palm of the right hand touches the fingertips of the left hand.

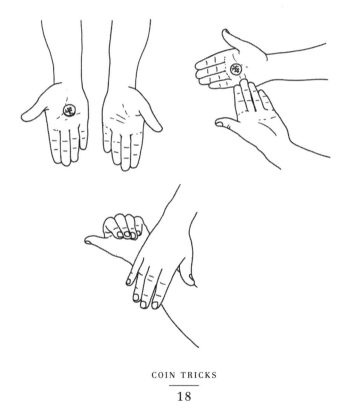

The legitimate move is to drop the coin into the left hand as the right hand passes over it, closing the fingers of the left hand over the coin and dropping the right hand to one side.

Now, to create the sleight, place the coin in the center of your right hand and close the fingers and thumb slightly, gripping the coin with your palm. This is called "palming." As you pass over the left hand with the back of the right hand to the audience, you can retain the coin in your right hand. This will take some practice. Getting the coin in the right position for the palm needs confidence and a little patter to bounce it around until it's right.

As before, practice the sleight and check in the mirror so it looks natural.

Outlined on pages 15–19 are three easy vanishes, but as I said at the beginning, it is the reappearance that is important. One great reappearance that can be used for any of the vanishes is called "cough up." It involves a little patter and a flourish.

At the beginning of the sleight, let the people watching know that you have a hole in the top of your head. Lean forward and let them look. Ask them if they can see it. They should say no and when they do, look a little confused and state that you can prove it. Smoothly perform one of the vanishes above, let's say the French Drop, but do not reveal the empty right hand. Instead, slap the top of your head with it. Then move your left hand to your mouth and cough, letting the coin drop. Catch it with your right. This really does look as if you have passed a coin through your head! Remember, it's smoothness that counts and if people ask you to do it again always decline. Don't give your tricks away too easily.

BUILDING A TREEHOUSE

———✦———

LET'S BE BLUNT. Building a decent treehouse is really hard. It takes something like sixty man-hours, start to finish, and costs more than $200 in wood and materials. In other words, it's a job for dads. You could spend the same amount on a video game console and a few games, but the treehouse won't go out of date—and is healthier, frankly. We are well aware of the satisfaction gained from nailing pieces of wood to a tree, but for something that looks right, is strong and safe, and will last more than just a few months, you need a bit more than that.

Along with a canoe or a small sailing dinghy, a treehouse is still one of the best things you could possibly have. It's worth the effort, the sweat, the cost, even the blood, if whoever builds it is careless with power tools. It is a thing of beauty. It really should have a skull and crossbones on it somewhere, as well.

You will need:

- Thirty 6-inch (15 cm) box head wood screws with heavy square washers
- Eight 8-inch (20 cm) box head wood screws with washers
- Thirty-two 4-inch (10 cm) box head wood screws with washers
- 4 × 3 inch beams—at least 16 ft, but better to get 20 ft (6 m)
- 2 × 6 inch (5 × 15 cm) pine planking— 64 ft (19.5 m)
- 2 × 4 timber for roof joists and walls— 32 ft + 152 ft (10 m + 46 m): 184 ft (56 m).
- Pine decking to cover the area of the platform—49 sq ft (4.5 sq m)
- Pine decking for the ladder—27 sq ft (2.5 sq m)
- Jigsaw power tool, electric drill, rip saw (Preferably an electric table saw)
- Level

- Large drill bits of 14, 16, and 18 mm
- Stepladder and a long ladder
- Safety rope
- Bag of roofing nails and a hammer
- Plywood—enough to cover four half walls with a total area of 84 sq ft (7.8 sq m). Add in approximately 49 sq ft (4.5 sq m) for the roof
- Ratchet with a set of heads to tighten the box head wood screws
- Chisel to cut trenches for the trapdoor hinges
- Two hinges
- Four eyebolts that can be screwed into the trunk
- Cloth bag for trapdoor counterweight

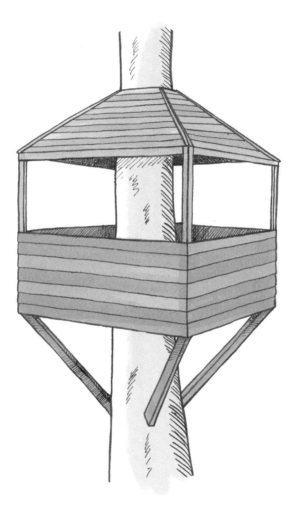

BUILDING A TREEHOUSE

24

To build the platform, you need some 2 × 6 inch (5 × 15 cm) pine planking, available from any large wood supplier. Our base was 7 ft by 7 ft (2.1 m × 2.1 m) and that worked out as eight 7 ft (2.1 m) lengths, with one more for bracers. Altogether: 64 ft (19.5 m) of 2 × 6.

Most dads will be concerned with making this as safe as possible. You really don't want something this heavy to fall down with children in it. Wherever possible, we went for huge overkill with materials, working on the principle that in the event of nuclear war, this treehouse would remain standing.

Choose your tree and check if the treehouse will overlook a neighbor's garden. If it does and they object, you could be asked to take it down again. Choose the height of the base from the ground. This will depend in part on the age of the children, but we put ours eight feet up. Higher ones are more impressive, of course, but are harder to make. If the ground is soft, use a board to stop the feet of the ladder from sinking in.

The Platform

The box head screws need to have holes predrilled, so make sure you have a suitable drill bit and a long enough extension cord to reach the tree. We ended up using three cords attached to one another and a double socket on the end. For a previous job, we had attached a table saw to an old table and it proved extremely useful to be able to cut wood as required.

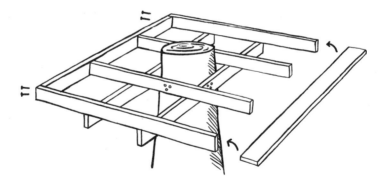

7ft. square frame built around top pair of boards using (2×6). Two 6-inch box head screws to each corner. Planks attached to tree with three 6-inch box head screws.

Build the platform as shown in the diagram opposite. Use the safety rope to support the planks until they are secure, putting the rope over a higher branch and tying it off when they are in position. Do not try to walk on the platform before it is supported at each corner. For it to drop, it would have to sheer off a number of steel box head screws, but the turning force of someone standing on a corner is huge and could be disastrous.

Supporting the Platform

Beams measuring 4 × 3 inches (10 × 7.5 cm) are incredibly strong—probably far too strong for the job. Given that the trunk is likely to be uneven, they will almost certainly have to be different lengths. First cut them roughly to size, being generous. The hard part is cutting the joint where the top of the beam meets the platform.

The strength comes from the fact that the platform sits on a flat surface at all four corners. The joint for this looks a little like a bird's open mouth. Cut it by hand, marking it out carefully. The first task is cutting a 90-degree triangle with two saw lines.

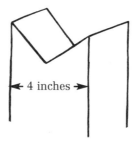

Mark a point 4 inches (10 cm) from the end on both sides, then draw a line to it from the opposite edge. Repeat to give you two diagonal lines. Where they meet is a neat center point. Measure it all twice. Cut from the edge inward.

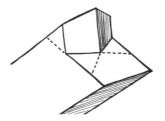

The second and spatially trickier cut is straight down on one of the cut edges. Again, measure carefully and cut. It might be worth practicing on a bit of scrap wood first. You should end up with four ends

that fit neatly inside the corner of the main platform and support it as well.

Eight-inch (20 cm) box head screws might seem excessive to attach the four diagonals to the trunk, but everything rests on them. Drill through the 4-inch length of the diagonal beam, so another 4 inches of steel goes into the tree.

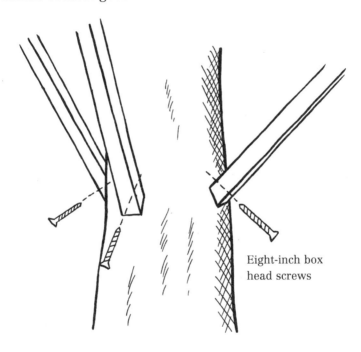

Eight-inch box head screws

Don't worry, you won't kill it. Trees are very resilient and a good pruning does more damage than this.

When the four diagonals are in place, the platform cannot tip without actually crushing one of them. This is practically impossible. We tested the strength by putting six adults up in the finished treehouse, with a combined total of more than 840 lbs (380 kg).

We used offcuts of 2 × 6 to add bracers to any spare gap in the platform. Rather than being another example of our usual overkill, this was used to support the decking. Make sure you leave a gap for the trapdoor. We used standard pine decking available from any home improvement store. It has the advantage of being treated against dampness— as were all the timbers here. Getting them treated is a little more expensive but makes the difference between a treehouse lasting ten years and twenty. We screwed the decking straight into the bracers and main beams of the platform, using a jigsaw to shape it around the actual trunk. Leave a little gap to allow for tree movement and somewhere to sweep dust and dead leaves.

THE WALLS

It is easiest to assemble these rectangles on the ground, then hoist them into place. That said, they are extremely heavy, so use ropes and two people at least. Do not attempt to lift the section without it being held by a strong rope.

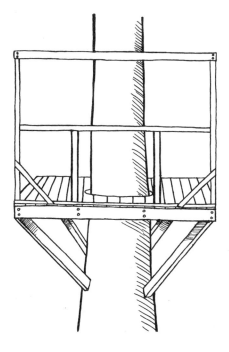

For each wall, 4×2 inch (10×5 cm) beams were used, with 4-inch box head screws holding them together. We planned to cover the lower half of each wall with overlapping shed planking, except for one left open with just wire to stop the children from falling through. It was absolutely crucial to have a drill powerful enough to send screws straight into the wood without predrilling. If we'd had to drill every hole first, we'd probably still be there now.

The shape was a simple rectangle with a ledge and a couple of support uprights. When you are deciding how tall it should be, remember that it is a treehouse for children. We went with 5 foot 6 inches, which was probably generous.

Each wall just sat on top of the decking and was screwed into it from above. Please note that it will feel wobbly at this stage. The four walls all support each other and when the last one is put into place, it becomes extremely solid. The roof will also add stability.

Also note that two of the walls will be shorter than the other two, so plan and measure these carefully or you'll have an awful time. You may also have trouble with the heads of the box head screws getting in the way. Although it's time-consuming,

you may have to countersink these with a ¾-inch (16/18 mm) wood drill bit. As well as the 4-inch box head screws, we used four 6-inch bolts and nuts to bring the sides together.

THE ROOF

Once the four walls are in place and solid, you can think about the roof. We used eight joists of 2 × 4. The length will depend on the angles involved, but allow at least 4 feet for each one.

Cut them roughly to size, then take out a triangle near the end so that they will fit neatly over the top corner of the walls. In theory, this is the exact opposite of the lower diagonals, but we didn't think it was worth cutting more "bird-mouth" joints.

Measure and cut very carefully here, as one end will be in contact with an uneven trunk. Use 6-inch box head screws (8) to anchor them to the tree. The roof supports only its own weight.

After placing the four diagonal joists for the corners, add four more joists between them, one to each side. Use a level to be certain they are all at the same height, or your roof will be uneven.

There are various ways of finishing a roof, of course. We used a plastic roof membrane tacked to the eight joists with roofing nails. Over that, we nailed strips of plywood. It looked very natural, but each piece had to be cut to size and then taken up the tree. We also nailed very thin battens on the diagonals for cosmetic effect.

The roof was probably the most time-consuming part of the whole process—and a good safety rope at that height was absolutely crucial. In fact, to reach the highest point of the roof, we had to stand on the window ledges, make a loop out of the rope, and sit on the loop as we leaned out. To say the very least, this is extremely dangerous and for dads only.

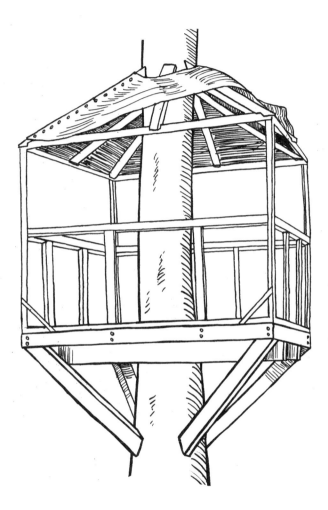

BUILDING A TREEHOUSE

35

Finally, we used the same overlapping planking to cover the lower half of the walls, then made a ladder out of decking planking. We attached the top of the ladder with loose bolts on the basis that it could be pulled up at some point in the future. It probably never will be, though—it is far too heavy.

We made the trapdoor from offcuts of decking and some pine planking, screwing it all together. To pull the trap door closed behind you, a piece of rope hanging from an eyebolt is perfect.

To prevent the trapdoor dropping on small fingers, it's worthwhile counterweighting it. To do this, get yourself a cloth bag of the sort you sometimes get shoes in. Run a rope through the trapdoor, with the knot on the underside. The other end should go through an eyebolt higher up the trunk and a third

one out on the wall. Tie the bag of stones to the end and leave it dangling where the children can reach it. To open the trapdoor from below, they can pull on the bag. To close it, they pull on the knotted rope hanging down from the trapdoor. You'll have to adjust the weight of the bag to suit the child, of course, and it means the trapdoor has to be pressed shut with a foot when you're up there, but it's much safer.

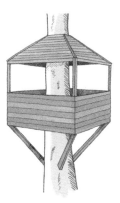

The important thing when it's all done is to wait for a nice summer evening, take some cushions, blankets, and a flashlight and spend the night up there under the stars. Take snacks—all that fresh air will give you an appetite.

SECRET INKS

A NYTHING ORGANIC (animal- or plant-based) that is clear or almost clear can be used as a heat-activated secret ink. Put simply, being organic means it contains carbon, and carbon things will burn. Milk, lemon juice, egg white, and, yes, urine will work as a secret ink. In the picture to the right, we used milk.

In our first attempt we wrote a sentence down the side of a letter. Unless you were looking for it, it wasn't easy to see. The letter on top helped to disguise it. We let this dry and then applied a flame directly to the hidden words. Try to avoid setting fire to the paper or your clothing. The letters appeared as if by magic.

You can read the words THE ARMY LANDS AT MIDNIGHT. Though it sounds very dramatic, this is a clumsy sort of message. Far better to have your spy waiting for a time, then put "mid" somewhere on the piece of paper. That would be much harder to find.

The trouble with this sort of thing is that the cover letter must look real, but not so real that your spy

THE ARMY LANDS AT MIDNIGHT

Hello David,

Just a quick note to say
how much we enjoyed
the party.

See you in the new year

Susan

doesn't look for the secret message. As with the section on codes, some things work better with a little planning. Invent a sister—and then they will know that every letter that mentions the sister by name contains secret words.

Secret inks allow you to send confidential information by mail. If it's not expected, it's not at all likely to be spotted.

SECRET INKS

39

MAKING A BOW AND ARROW

——✦——

A T SOME POINT, you may consider making a bow and arrow. Perhaps because of the British history of using longbows at Agincourt and Crécy, firing an arrow can be immensely satisfying—not to hit anything, even, but just to see it fly and then pace out the yards. The bow in this chapter sent a heavy-tipped arrow 45 yards (41 m), landing point first and sticking in.

Despite the fact that English archers at the battle of Crécy fired arrows *three hundred yards* (275 m), the first flight of our arrow was a glorious moment for us. The current world record is held by Harry Drake, an American who, in 1971, fired an arrow while lying on his back, a distance of 2,028 yards (1854 m)—more than a mile (more than a km).

Don't spoil such moments by doing something stupid with yours. The bow and arrow here could be used for hunting or target practice in a garden. Remember at all times that it is a weapon. Weapons are never pointed at other children.

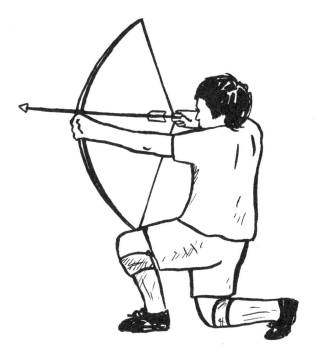

MAKING A BOW AND ARROW

Arrows and Arrowheads

You will need:

- Flint or bone for arrowheads
- Soup can
- Strong scissors and pocket knife
- Straight 4 ft (1.2 m) lengths of springy wood—elm, ash, or yew
- Straight 1 yd (0.9 m) lengths for arrows
- Thread, glue
- Phillips screwdriver
- String
- Feathers, usually found, or bought from a butcher
- Strip of leather to protect fingers

There are a number of ways to make an arrowhead. Stone Age man used flint, and it is still intriguing to make a simple arrowhead with this material. Flint is the fossilized remnant of small organisms and it is extremely common. Our selection came from a

ploughed field that was absolutely littered with pieces bigger than a fist. It is usually found with chalk—on what was once the bed of an ocean millions of years ago.

Find yourself a nice big piece. One of the very few benefits of wearing glasses is that your eyes are better protected from shards. If you don't wear glasses, look away or wear goggles as you bring it down sharply on another flint lump.

You'll find that with enough of an impact, flint breaks like glass, forming razor-sharp edges that almost instantly suggest axeheads and arrows. We found that with a bit of luck, five or ten of these impacts would give you a handful of suitable pieces—shards that look as if they could be shaped into an arrowhead.

You may have seen pictures of Stone Age flints with a series of scalloped semicircles around the edge. These circles are formed by "knapping" (sometimes spelled "napping"), which is a difficult skill. Many people still do it as a hobby, producing ornate as well as functional arrowheads.

Using a pointed implement such as a small Phillips screwdriver, it is possible to chip away at the sharp

edge of a flint until the right shape is achieved. Place the flint on a piece of soft wood, with the edge touching the wood, then press the screwdriver head downward against the very edge.

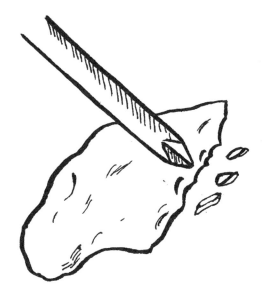

It's a slow and tiring process, but it does work and if it was the only way to kill a deer to feed your family, the time would be well spent. A grindstone, patience,

and spit can also produce quite decent arrowheads, though without that classic look. A combination of the techniques would also work well.

Remember to leave enough of a "handle" to bind into the arrow shaft—and expect to have a few break in half and be ruined before you have one you like.

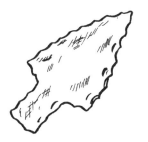

The next one we produced with only a grindstone. It is very small at ¾ in (17 mm) long—but much larger and the arrow range would be reduced.

Bone also works well—and can be shaped on a sanding block very easily. We found that if you give a lamb bone to a big dog, the splinters he leaves behind can be turned into arrowheads without too much trouble. But never give your dog chicken bones.

The easiest arrowheads to make come from tin cans—baked beans, Spaghetti Os, anything. The base and lid will be a flat metal surface. Use a good pair of scissors, and you might find it is very easy to cut yourself and spend the rest of the day at your local hospital. Ask your dad to help with this bit. Leave a long "handle," as in the picture. It will help keep the head securely in place.

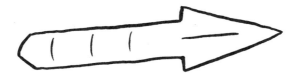

Note that these are not that useful for target practice—they bend. They are probably better for hunting rabbits, though we found the movement of drawing an arrow scared living creatures away for half a mile in every direction. For target practice, the best thing is simply to sharpen the wooden arrow tip with a pocket knife and use a soft target—an old sweater stuffed with newspaper or straw.

The arrows themselves are traditionally made out of very thin, straight branches, whittled, trimmed, and sanded until they are perfectly smooth. Dowel rods, however, are already perfectly straight and smooth and can be bought from any large hardware store. The arrow we made is from an English elm, but any wood that doesn't splinter will easily do.

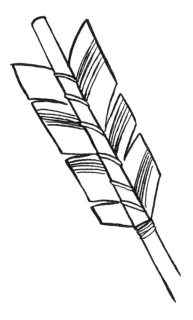

There are three important parts to making an arrow—getting it straight, attaching the point, and attaching the feathers. The old word for "arrow maker" was "fletcher," and it is a skill all by itself.

If you have a metal tip, simply saw a slit in the end of your arrow, push the head into place, and then tie strong thread securely around the arrow shaft to keep it in place. Attaching a flint head like this is only possible if it is a flat piece.

Now, to fletch the arrow, you are going to need feathers. We used pheasant feathers after seeing a dead pheasant on the side of the road. If this isn't possible, you'll have to go to any farm, ask at a butcher's, or look for pigeon feathers in local parks. Goose feathers are the traditional favorite, but are not easy to find. Make sure you have a good stock of them at hand. Feathers are much lighter than plastic and are still used by professional archers today.

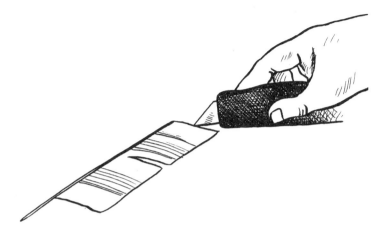

With a pocket knife, or just scissors, cut this shape from the feather, keeping a little of the central quill to hold it together. You can still trim it when it's finished, so it doesn't have to be fantastically neat at this stage.

You should leave an inch of bare wood at the end of the arrow to give you something to grip with your fingers as you draw. We forgot this until actually testing the bow.

Also note that the three feathers are placed 120° apart from each other (3 × 120 = 360). The "cock feather" is the one at 90° to the string slot, as in the picture below. Use your eye to place them on the shaft for gluing. During a shot, the arrow rests on the outside of the hand gripping the bow and the cock feather points toward the face of the archer. The other two feathers can then pass the bow at speed without hitting it.

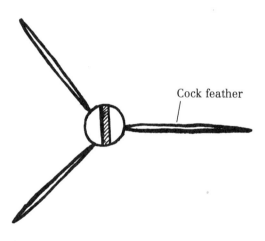

Cock feather

MAKING A BOW AND ARROW

A touch of glue holds the feathers in place, but for tradition and for the look of the thing, you should tie a thread securely at one end, then wind it carefully through each of the three feathers until you reach the other end. This is a tricky job, but strong thread will create an arrow that is a joy to behold. Tie both ends off carefully, trimming the ends of the thread.

It's a good idea to prepare five or six of these arrows. There is an excellent chance you are going to break a couple, or lose them. Use a little common sense here and don't launch them where they can disappear into someone else's garden.

The Bow

Ideally, the wood for your bow should be straight and springy. It should be cut green and then left somewhere to dry for a year. However, our childhood experience of bow making was that they were always made on the same day they were cut, so we did that again here. Elm works well, as does hazel and ash. The most powerful bows come from a combination of yew sapwood and heartwood, the dense hedge tree found in every churchyard. In earlier times, Druids considered yew trees sacred and built temples close to

them, beginning an association with places of worship that continues to this day. The red yew berries are extremely poisonous. Do not cut yew trees. They are ancient.

Freshly cut bows do lose their power after a day or two. They should not be strung unless you are ready to shoot and you should also experiment with different types of local wood for the best springiness.

The thing to remember is that the bow actually has to bend. It is tempting to choose a thick sapling for immediate power, but anything thicker than ¾ inch is probably too thick.

MAKING A BOW AND ARROW

If you have access to carpentry tools, fix the bow gently into a vise and use a plane to taper the ends. Most ones you find in woods will have some degree of tapering, which can be corrected at this stage.

We cut all the notches and slots for this bow and arrow with a standard Swiss army-knife saw blade. However, a serrated-edge bread knife would do almost as well.

Cut notches in the head and foot of the bow, 2 inches from the end. You want to cut them just deep enough to hold the bowstring without slipping.

You'll need very strong, thin string—we found nylon to be the best. Fishing line snapped too easily. Traditional bowstrings were made from waxed linen or woven horsehair, forming miniature cables of immense strength. The Romans even used horsehair to form great springs for their war catapults!

The knot you'll need is a good all-rounder, used for tying up a canal boat or stringing a bow. Its advantage is that the actual knot isn't tightened under pressure, so it can always be loosened when you need to move on. It is called "the round turn and two half hitches."

First wind your rope fully around the bow end, as shown. This is the "round turn." Then pass the end

under the bowstring and back through the loop—a half hitch. Pull tight. Finally, do another hitch in the same way: under the string, back through the loop, and away. You should end up with a knot that doesn't touch the bow wood but is very solid.

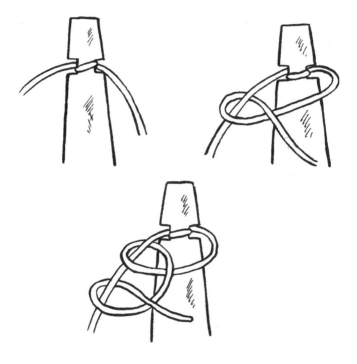

As a final note, it is a very good idea to wear a glove on the hand that holds the bow as you draw back the string. The arrow passes over it at speed and can take skin off. Also, we found it much easier to pull the string back if we had strips of leather wound around the second and third fingers. You can probably get a piece of leather from a furniture shop as a sample, or an upholsterer's scrap bin. Alternatively, you could just wear another glove. It may interest you to know that the rude gesture of sticking two fingers up at someone came from the English archers at Agincourt. The French had said that they would cut off the arrow-pulling fingers of those men when they beat them. Instead, the French were defeated and the archers mocked them by showing off their fingers—still attached.

Archery can be a fascinating and highly skillful sport, and this isn't a bad way to start.

TWO QUICK THINGS TO DO

MAKING AN ACORN SPINNER

Very simple, this, but it works so well it's surprising more people don't know about it.

Take an acorn from underneath an oak tree and push a matchstick into the top as you see here.

With just a little practice and a smooth surface, you'll find it makes a very good spinning top. Twist the matchstick between a thumb and a finger as fast as you can as you let it go.

Stress Ball

Buy the biggest balloon you can find and instead of blowing it up, fill it with a couple of handfuls of flour and tie a knot in the end without leaving any air inside. It feels exactly like a stress ball and is oddly relaxing to squeeze. The bigger the balloon, the thicker the rubber and the longer it will last until you end up with a pocket full of flour; well-worth remembering.

FIVE PEN-AND-PAPER GAMES

———✦———

1. HANGMAN

This is the classic word game for two or more players. Think of a word and mark out the number of letters in dashes – – – – – – –. The other player guesses letters one at a time. If they guess correctly, write the letter over the appropriate dash.

If they get one wrong, draw a line of the hanged man and write the letter on the page. Incorrect guesses of the whole word also cost a line.

There are twelve chances to get the word right. If the hanged man is completely finished, they lose. Take it in turns and try some really hard words, like "paella," or "phlegm."

2. Houses

This one is silly, but enjoyably frustrating. It looks very easy. Draw six boxes anywhere on the page. Mark three of them with G, E, and W—Gas, Water, and Electricity. Number the others 1, 2, and 3. The object of this puzzle is to provide vital services to the three numbered houses. You do this by drawing a pipeline from one to the other. Lines are not allowed to cross and they may not go through a house or a service station.

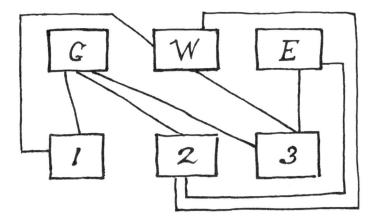

In the example, you can see one of the houses has Gas and Water but no Electricity. Try moving the squares around but remember, you are not allowed to cross any lines. This puzzle looks possible, but it actually isn't. No matter where you put the boxes you cannot connect all three services without crossing a line. It is perfect to give to someone who thinks they are really clever (like an elder brother). It will completely outfox them. Pretend you know the answer, refuse to tell them and watch them struggle.

(There is a cheating way to complete the puzzle. You take the last pipeline out to the edge of the paper, run it back on the other side, and then punch a hole through to the house. This does not impress onlookers.)

3. Squares

This is a very simple game for two players that can be fiendishly difficult to win. Draw a grid of dots on a piece of paper, say nine by nine or ten by ten. Each player can draw one line between two dots in his or turn. The aim is to close a box, making a square. If you can do this, you get another turn.

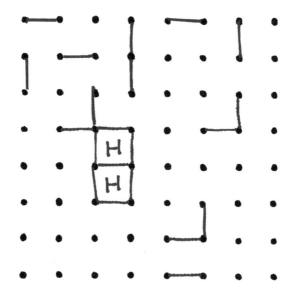

The game tends to follow a pattern of easy steps as most of the lines are filled, then sudden chains of boxes made, one after another, until the grid is complete. It may be a good idea to sacrifice a small line of boxes so that a larger one is yours. Mark the boxes clearly so they can be counted—either with different colors or a symbol. The player with most boxes in the end wins.

4. Battleships

This is a classic. Two grids are drawn, with x and y axes numbered 1–10 and A–J. Larger grids will make the game last longer. Draw ships on your grid—an aircraft carrier of five squares, a battleship of four, two destroyers of three, a submarine of two, and another cruiser of two. Any reasonable combination is possible as long as both players are in agreement.

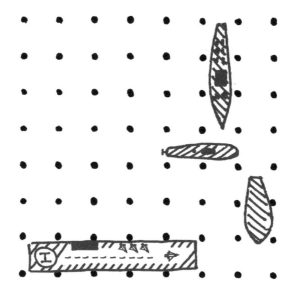

Once these have been drawn in private, each player then calls out shots in turn, using the grid references—A4, C8, and so on. The aim is to sink your opponent's ships before yours are sunk.

An interesting alternative is to replace the ships with words chosen by each player—of two letters, three letters, and so on. The aim is still to find and "sink" the words, but with a score of five points for every word—or *ten* points if the word can be guessed before the last letter is hit. The winner is the one with the most points in the end.

5 . OTHELLO

Another one that looks easy but is in fact fiendish. Begin by drawing a grid with a pencil—school-exercise books always make these things easier, which may be why an awful lot of these games are played at school.

Three by three is not enough of a challenge but will do for an explanation. Five by five is much better.

The player using *O* fills in two corners, while the opponent puts an *X* in the other two. Decide who moves first by flipping a coin.

Each player can only place a symbol on adjacent squares to the ones he already has. You can't "move" diagonally.

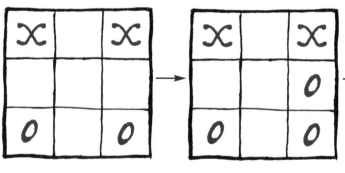

1 2

Any of the opponent's adjacent symbols are changed into yours by the move—including diagonals. In diagram number 2 it would make sense to place an *O* in the middle-right square.

You'll need an eraser! The *X* in the corner will be erased and turned into an *O*.

Of course, now *X* can respond. If he put his *X* in the middle of the top row, it will win two more *X* squares . . . and so on. In fact, *O* must win this one.

The game ends when one player has nothing left, or when the grid is filled. This is just a teaser. With larger grids, the game can be fascinating and complex.

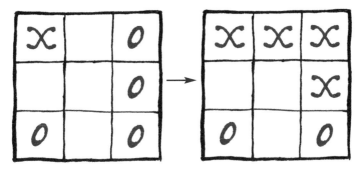

3 4

JUGGLING

THIS IS THE SKILL of tossing objects in the air and catching them. First of all you will need three round balls, about the size of tennis balls. You can make excellent ones by putting a couple of handfuls of rice or flour into a balloon. If you use fruit, it will be very messy, so be prepared to eat it bruised. Alternatively, juggling balls can be bought from any toy store. It looks difficult, but on average it takes about an hour to learn, two at most.

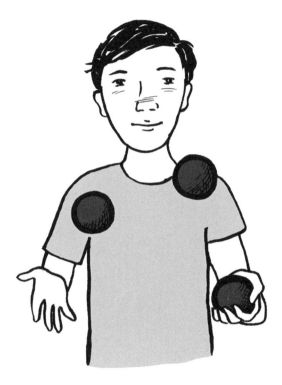

1

2

3

1. Hold one ball in your right hand and gently toss it into your left. Now toss it back in the direction it came. Go back and forth with this until you are comfortable.

2. Now let's add another ball! Hold one ball in your right hand and one in your left. As you toss the ball from your right hand to your left, release the ball in your left hand and catch the incoming ball. The hard part is releasing the left-hand ball so that you toss it back to your right hand and catch it. This will take some practice, or you might pick it up immediately. Make sure both balls are flowing in a nice arc from hand to hand. This will give you more time to release and catch.

3. Ball three! Hold two balls in your right hand. Hold the third ball in your left hand. Toss the first ball from right to left and as you catch it in your left hand, release the second ball, tossing it back to your right. (This is just step 2, holding a third ball.)

The hard part is releasing that third ball as you catch the second ball in your right hand, and tossing

the third ball back to your left hand. You must keep this toss-release-catch going from hand to hand. Practice, practice, practice!

Now for a neat trick. Start in the beginning position (two balls in the right hand, one in the left), put your right hand behind your back and throw the two balls forward over your shoulder. As they sail over to the front, toss the left hand ball up as usual and catch the two coming over in your left and right hand. Yes, this is as hard as it sounds. Quickly toss the right-hand one to your left and catch the one in the air coming down. Now you are getting into the routine. This is an impressive start to juggling three balls, but it is very hard, so the best of luck.

THE LIGHTBULB-IN-A-TIN

———◆———

THIS IS AN EXTREMELY simple circuit toy that will be instantly recognizable. It is also fun—and portable. You will need a tobacco tin—and they're not easy to find these days. Ask at garage sales, or bother the elderly. Try to get more than one, in fact, as they are fantastically useful.

You will also need:

- A battery—ideally one of the square nine volt ones
- A flashlight bulb
- Two pieces of bared wire about the length of a ruler
- Duct tape

If you have access to a soldering iron, soldered connections are more reliable, but this can be made without.

1. Attach one wire to the positive terminal of the battery (+). If you do use a soldering iron, make sure the battery is firmly held and don't rush—it isn't easy to place a blob of solder where you want it without it cooling down too fast.

2. Attach the end of the other wire to the end of the bulb, as in the picture. We soldered it. Using small strips of tape, you could hold it steady, but try not to cover the barrel of the bulb—you'll need it for the last connection. Make a loop out of the other end, as shown.

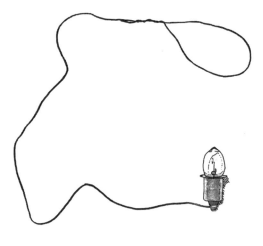

THE LIGHTBULB-IN-A-TIN

3. Attach the socket of the bulb to the other battery terminal. Note that the bulb should go sideways rather than be pointing up, or the tin might not close properly. This a good point to try the circuit. With the bulb in contact with the anode (–), the bulb should light when the wires touch. If it doesn't, check each connection—and make sure the bulb works.

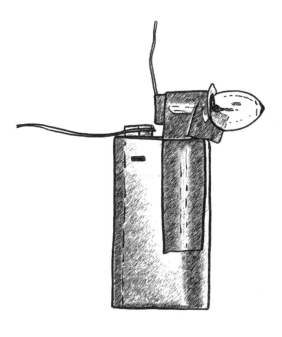

THE LIGHTBULB-IN-A-TIN

You now have a circuit that will light a bulb when two wires touch. Install it in the tin with more tape.

To use, bend one wire into a series of curves and use the loop to go from one end to the other without touching. Here is where you need a steady hand.

There is a slight chance the wires will form a circuit through the metal of the tin, so it's not a bad idea to line it with the tape. At the time of writing, ours has lasted more than a year without breaking or the battery wearing out—despite regular use.

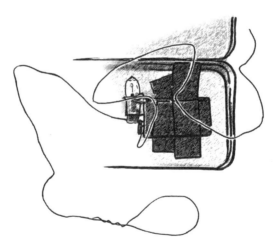

THE FIVE KNOTS EVERY
BOY SHOULD KNOW

———✳———

BEING ABLE TO TIE A ROPE in knots is extremely useful. It is amazing how many people only know a reef and a granny knot. Rather than naming hundreds, we've narrowed it down to five useful examples.

However, they take endless practice. I learned a bowline on a sailing ship in the Pacific. For three weeks, I used an old bit of rope on every watch, night and day. On my return to England, I attempted to demonstrate the knot—and found it had vanished from memory. To be fair, it didn't take long to recall, but knots should be practiced every now and then, so they will be there when you need them. There are hundreds of good books available, including expert levels of splicing and decorative knots. The knots demonstrated here are the standard basics—useful to all.

1. The Reef Knot

This knot is used to reef sails—that is, to reduce the amount of sail area when the wind is getting stronger. If you look at a dinghy sail, you'll notice cords hanging from the material. As the sail is folded up on the boom, the cords are tied together using reef knots. It is symmetrical and pleasing to the eye.

The rule to remember is: left over right, right over left.

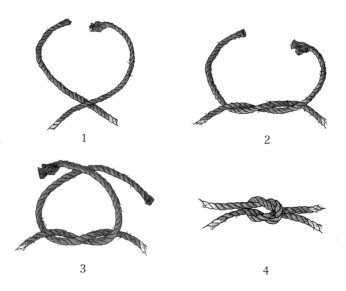

1

2

3

4

2. THE FIGURE OF EIGHT

This is a "stopper"—it goes at the end of a rope and prevents the rope from passing through a hole. A double figure of eight is sometimes used to give the rope end weight for throwing. It's called a figure of eight because it looks like the number.

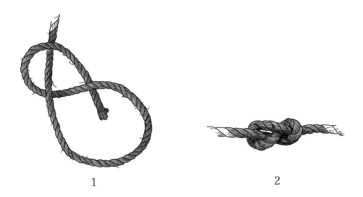

1

2

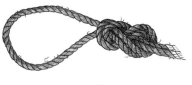

3

3. THE BOWLINE (PRONOUNCED *BOW-LIN*)

This is a fantastically useful, solid knot. It is used whenever a loop on the end of a rope is needed—for a post, a ring, or anything else really.

i. Make a loop pointing toward you, leaving enough free at the end to go around your post, tree, or similar object.
ii. Now—imagine the loop is a rabbit hole and the tip is the rabbit. The other end of the rope is the tree. Feed the tip up through the hole—the rabbit coming up.
iii. Pass the rabbit around the back of the tree.
iv. Pass the rabbit back down the hole—back into the original loop.
v. Pull tight carefully.

NOTE: You can make a simple lasso by making a bowline and passing the other end of the rope through the loop. The bowline does not slip, so it is useful for making a loop to lower someone, or to throw to a drowning person.

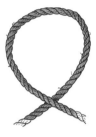

i

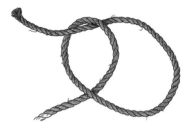

ii

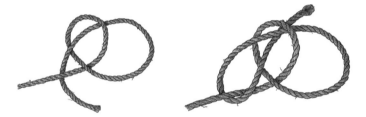

iii

iv

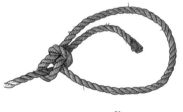

v

THE FIVE KNOTS EVERY BOY SHOULD KNOW

4. Sheet Bend

This is a useful knot for joining two ropes together. Reef knots can fail completely when joining ropes of different diameters—but a sheet bend works very well.

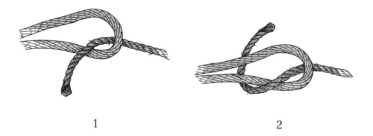

1

2

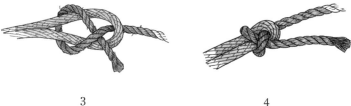

3

4

5. A Clove Hitch—for hitching two things together very quickly

This is a short-term knot—the sort of thing you see used by cowboys in westerns to hitch their horses. Its main benefit is that it's very fast to make. Basically, it's wrapping a rope around a post and tucking an end into a loop. Practice this one over and over until you can do it quickly.

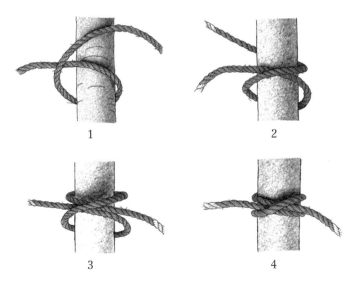

1

2

3

4

These five knots will be useful in a huge variety of situations, from building a treehouse to camping, to sailing, to tying up your horse outside a saloon. They will not come easily. They take practice and patience. Knowing this will not impress girls, but it could save your life—or your horse's.

MAKING A QUILL PEN

A T SOME POINT in childhood, everyone finds a large feather and wonders how hard it would be to make a proper quill pen, of the sort Shakespeare used. In his day, he would have bought goose feathers. Being right-handed, he would have needed feathers from the right wing of the goose. They bend away from the right-handed writer's face while he is writing. As a result, they were a little more expensive than left-wing feathers.

Unless you are very lucky, the feather you'll have is probably from a crow or a pigeon and not really large enough to worry about which way it bends. The larger the feather, the better, when it comes to making a quill pen.

You could begin cutting immediately, but you'll have much better results if you soften the feather first. To do this, leave the feather standing in water overnight. If you don't have time, dunk it in hot water until it goes soft. After that, fill a small kitchen pot with sand and heat it in the oven at around 350°F for about twenty minutes. This is definitely a job where your dad can

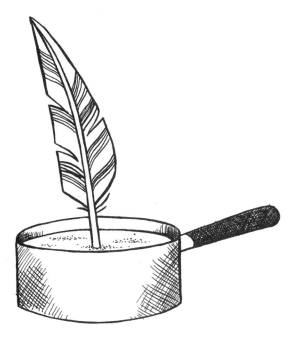

help. Take it out using oven gloves and poke the sharp end of the feather into the sand, leaving it until it has cooled.

The tube of the feather will be firmer and easier to shape after this process. It should also last longer before needing to be resharpened. Strip away some of the feathers near the point with a knife or scissors, so they don't get in the way.

The reason a penknife is called a "penknife" is because it came into existence as a small knife used for sharpening quills. Any very sharp blade will do for this, but it is satisfying to use a Swiss army knife for its original purpose.

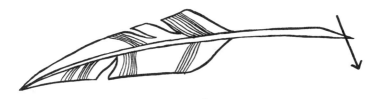

The first cut is at about 45°, as you can see here. It looks like the wrong way around, but you'll see why in a moment.

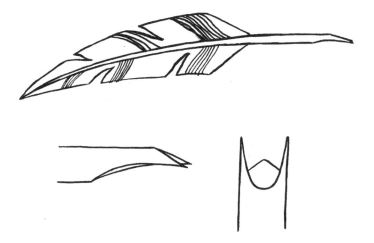

The second cut is on the underside of the quill, a longer, tapering cut as you see here. It will form two horns at the end.

There is a dry membrane running down the center of the feather. Take it out with tweezers or the point of the penknife.

Now, if you have softened your quill, you should be able to press the two horns together and hear a snapping sound as a crack appears between them. As with a modern fountain-pen nib, the crack will help the flow of ink. It should be as central as possible.

The remaining cuts are more like taking shavings

off the underside of the nib to the new point at the crack. You should aim to have a curving surface, as you can see below. This is not something to rush.

The aim is not to come to a perfect point—it will be too scratchy and send ink spattering across a page. You might try to bring it to a point, then cut a crossways slice across the tip to give it a little more width.

"Use makes master" as they used to say, another way of saying "practice makes perfect."

Finally, get some good-quality paper and ink, dip it, and have a go at writing. You will probably find that you don't envy Shakespeare his writing materials, but it's still satisfying to know how to do something right, especially a skill as ancient as this one.

MAKING A QUILL PEN

TABLE FOOTBALL

THIS IS A SIMPLE GAME, but it does require some skill and practice. It used to keep us occupied during French lessons.

You will need:

- A flat, smooth surface—a school table, for example
- Three quarters are best

1. Place the coins on the close edge of the table, as in the diagram. The first blow must be struck with the heel of the hand against the coin that is half over the edge. The three coins will separate. From then on, only the coin closest to the player can be touched.

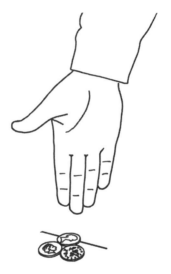

2. The aim of the game is to pass the coins up the table by firing the closest through the two farther up. If you don't get the coin through, that's the end of your turn and your opponent begins again

from his side of the table. Just one finger is usually used to flick the coins. They should always be in contact with the table, so a great deal of the skill is in judging the force as well as planning ahead.

3. After a few of these "passes," the opposing goal comes into range. This is provided by the other player, as shown.

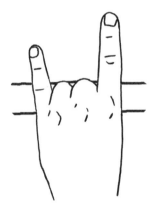

4. If the goal shot misses, the game is lost. If the shooting coin strikes one of the other two, the game is also lost.

In the advanced version of the game, tries are scored rather than goals, and they are worth five points. The scorer then has an opportunity to gain two more points by converting the try. This is difficult, to say the very least.

1. The opposing player rearranges his goal into a goal-post formation, as in the illustration.

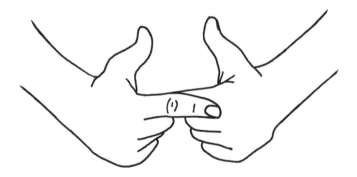

2. The goal or shooter coin must first be spun in place. As it spins, the coin must be gripped, as shown in the picture, and flipped over the posts in one smooth motion. No hesitation is allowed for aiming. This is not at all easy to do, which is as it should be.

3. Play up to an agreed number of points, perhaps to win the coins.

FISHING

⟨⎯⎯✦⎯⎯⟩

FISHERMEN ARE *NOT* PATIENT. Anticipation and concentration can make fishing an exhausting sport. It is mainly a solitary occupation. You hardly ever see people fishing in groups, laughing and chatting with one another, or drinking alcohol and singing. Fishermen can spend the day in silence. Even if you never catch anything, lazy afternoons spent fishing in the summer can be relaxing, rewarding—and addictive.

A simple starter kit—a rod, bait, a float, a lead weight, and a hook—can be put together for about $60. Check your state and local laws to see what permits may be required. You may need to purchase a license.

The local fishing store will have equipment and should be able to give you good advice about licenses and local fishing grounds.

Otherwise, any canal or good-sized freshwater river will do. You may be asked to pay a small extra fee for a day's permit. If expensive fish like trout or

salmon are involved, you will almost certainly be asked to show your license and be required to get the owner's permission. Technically, fishing cannot be poaching as fish are *ferae naturae*—wild animals.

The classic fishing method is with a float. Maggots from bluebottle or greenbottle flies are spiked on a hook suspended from a float that bobs on the surface. Push the hook through the blunt end of the maggot, taking care not to burst it, as a burst maggot dies faster.

It is often necessary to place a couple of ball lead weights on the line to keep the float upright. Ask in the fishing store if you're not sure how.

Cast carefully, as a hook catching in your eyebrow is a deeply unpleasant experience. Watch out for overhead cables or tree branches. Your basic reel will have two settings—one for casting and one for retrieving the hook. Allow it to unravel and cast the hook and float upstream, then allow the hook to come downstream toward you in the current. The first moment when that float dips is an experience to be treasured. Otherwise, wind back in slowly and try it again, replacing your maggots when they no longer move. If it's a nice day, find a place to sit and enjoy the peace that lasts until someone comes along and says, "Any luck?"

The second classic method involves a heavier lead weight that keeps the hook on the bottom. Fish taking the bait feel no resistance. This works well with carp.

It should be clear that the method depends on the fish. Pike and perch tend to attack injured or dying fish. As a result, they can be caught using a "spinner," a device that resembles a wounded fish as it moves through the water. Many fisherman use complex lures that mimic insects on the surface. For a beginner, though, you'd hope to catch one of the following:

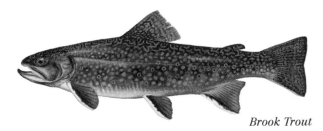

Brook Trout

Brook trout (*Salvelinus fontinalis*). A group of trout is called a hover, and these can usually be found in spring-fed lakes, streams, and ponds with sand and gravel bottoms. This is a beautiful, speckled fish that eight states, including Vermont and New York, claim as their official symbol.

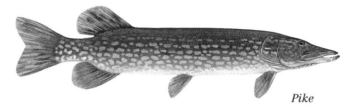

Pike

Pike (*Esox lucieus*). Pike are greenish with bright yellow eyes, and while they usually weight a few pounds when you catch them, old fish that have avoided the lure for years can reach up to twenty pounds.

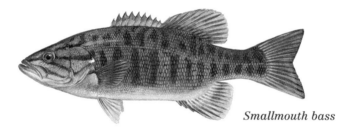

Smallmouth bass

Smallmouth bass (*Micropterus dolomieui*). Bass are green with a white underside. They love to eat crayfish, but in the winter, they fast and hide at the bottom of lakes and rivers. You might also encounter the largemouth bass, which is almost identical to its smaller cousin.

Minnow

Minnow. The tiny fish whose name has actually come to mean "small and insignificant."

Walleye

Walleye (*Stizostedion vitreum*). Walleyes, the favorite game fish of many Americans, especially in the Midwest, are really huge perch, and taste just as nice. Walleye season starts in the middle of May.

There are too many other types to include here—the rivers and lakes teem with them.

"Game fishing" is a specific reference to the salmon family: salmon, trout, char, and grayling. "Coarse" fish

have five fins—ventral, anal, dorsal, pectoral, and caudal. Members of the salmon family all have one extra fin close to the tail—known as the adipose fin. Salmon are born from eggs laid in rivers and swim to the sea, where they live for one to three years. After that, they return by instinct to the river where they were born to breed, in what is known as the "spawning season." They are caught as they travel upstream, with a lure containing a hook.

Catching a fish can be exciting—the real skill is not in hooking one but in bringing it in without breaking the line or losing the fish. As a final note, try reading the classic fishing tale by Ernest Hemingway—*The Old Man and the Sea*. Happy fishing.

MAKING A PERISCOPE

THIS IS A QUICK and easy one. It took just over an hour to put together once we had everything at hand. It does, however, involve work with a saw, hammering, and glue, so if you are unsure, ask for help.

You will need

- Saw, hammer, glue, small tacks
- Two mirrors—2 × 2 in (5 × 5 cm)
- Plywood—three-ply or five-ply. Cut two pieces of 18 × 2 in (45 × 5 cm), two pieces of 16 × 2 in (40 × 5 cm), two end pieces of 2 × 2 in (5 × 5 cm)
- Duct tape

First get yourself two small square mirrors. Any glass shop will cut a couple of pieces for you. Ours cost about two dollars each, which is a high price, considering what they are. You may well do better. For the actual periscope tube, we used plywood we had lying around. Ours was five-ply, which is more robust than you actually need. Three-ply would be better and is also easier to cut.

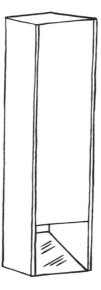

MAKING A PERISCOPE

A periscope works by reflecting light from one mirror to another and finally to the eye. Its simple effect is the ability to look higher than your head. It can be used to peer over fences or check enemy positions without exposing yourself to sniper fire. The classic use is in submarines.

MAKING A PERISCOPE

We used small tacks to create the box, leaving a space (at the top of one side and the bottom of the other) for the mirrors. We kept ours simple and fairly rough, though obviously your periscope can be smoothed, painted, or even joined and glued properly if you want one that could survive a generation or two. As a woodwork project in mahogany with brass corners, it would be very impressive.

The only difficulty was in securing the mirrors. By far the best way is to glue tiny wood strips in place on the inner surfaces, like runners. The mirrors slide between the strips and lock neatly into place against the end pieces. We used heavy insulation tape, however, and that seemed to do the job almost as well.

Having relied on the tape, it seemed sensible to cut one of the 16-inch sides down to 14 inches, so that the top mirror could actually rest on its edge. Obviously, if it sat on neat little wooden runners, it would be perfectly all right to leave the piece at 16 inches, for a neater look.

The angle of the mirrors should be 45° for the right reflection. This isn't easy to judge, however, and the easiest way is just to position the first mirror until you can see the other end of the periscope tube

in it. Once that is secured, position the second by hand, marking lines so you can find the correct position easily. Then either tape it or glue the wooden runners.

In theory, you could build quite a long periscope. We found 18 inches was about right for our mirrors, but you could use larger pieces and experiment with a longer box.

DOG TRICKS

T EACHING A DOG simple tricks helps to build the bond between you. Dogs enjoy pleasing their owners and a well-trained dog is a happy dog! The only difficulty is in making the dog understand what you want. Commands should be given in a low, firm voice. Don't expect them to understand perfectly the first time. Be prepared to come back to the same commands again and again, leaving a few days between. Most dogs are perfectly willing to jump through hoops (literally) for their owners.

1. "Speak"

This comes under the group of tricks that come from observed behavior. If a dog does something and a command word is uttered and a treat given every time, it will quickly associate the treat and the pat with the command word. Say "Speak!" when it barks and in a short time, it will bark on command. Saying "Are you sleepy?" when it yawns works in exactly the same way.

2. *"Sit"*

Everyone is familiar with this one. It is important that a dog knows when to pause at every curb rather than rush across the street. Sitting helps to mark this importance. Repetition is key here—even bright dogs like collies can take two years to become well trained. Do not expect overnight results with any of these.

Press the dog's hindquarters down firmly, while saying "Sit." Then give a treat—a piece of biscuit, for example. It doesn't have to be much. A pat on the head will probably do, but you'll find training easier with some sort of small reward to hand out.

3. "Down"

Always follows "Sit." Point firmly at the floor in front of the dog's head. As with teaching it to "speak," you might try this when it is on its stomach naturally. Otherwise, you can try placing it in the "down" position manually, then express delight and give it a treat. It should remain upright, like a sphinx.

4. "Play Dead"

Usually follows "Down." "Dying" involves lying completely flat on its side. You may have to press your hand gently against the dog's head to indicate what you want it to do. Dogs love this and though they lie still, their tails wag madly. Keep your voice very low and touch the tail, saying slowly, "Dead dogs don't wag . . ." Hold it for two or three seconds, then get them up and give it a pat and a treat.

5. *"Paw"*

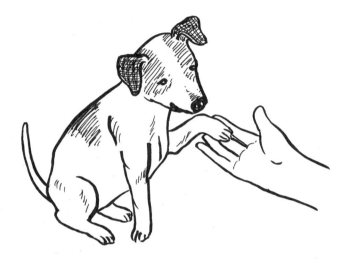

This is one you have to demonstrate. Simply lift the dog's paw in your hand and shake hands gently before giving them a treat. Follow with the command "Other paw" for it to swap the other. It won't be long before it offers paws on command. I had a terrier who took forever to get this, but he managed it in the end.

6. "Over"

This is used when you want the dog to run—to cross a street swiftly is the most common use. Train the dog by holding its collar and raising your tone in excitement, holding it back. When traffic is clear, say "Over!" loudly and let it run. It will probably not cross neatly the first few dozen times, so don't train it near cars.

7. "Heel"

Crucial when walking a dog on the leash. It is tiring and annoying to have a dog pull as it walks along. Curb the habit early with a sharp jerk of the lead and a very firm tone as you say the command word. Puppies are excitable and curious. They often take a long time to learn this. Be careful not to hurt them and do not worry about looking like a fool. Anyone who has ever had a puppy has walked along a road saying "Heel" over and over and over again without any clear effect. To state the obvious, the dog does not understand why you are calling out parts of your feet. You are setting up a link in its mind between the word and the action of being jerked back. It will probably take a good year for this to work, depending on how young the puppy is when you get it. Be patient. It's

good practice for controlling your temper when you have children later on. Seriously. Like a lot of things in life, early work bears fruit when it really matters.

8. "Stay"

This is another important one to teach early. Most dog owners have been surprised by a situation where the dog is far away and suddenly there's a car coming toward you. If you can tell the dog to "Stay" and have it remain still, a serious accident can be avoided. This is taught with the aid of a pocketful of treats and many afternoons. Have the dog sit and say "Stay!" in your deep command voice. Hold up your hand at the same time, showing the dog a flat palm. Take a step back. If the dog follows you, return it to the same spot and begin again. Begin with three steps and then give it a treat and a pat, making a big fuss over the dog. When it can remain still for three steps, try six, then a dozen and so on. You should be able to build up to quite long distances in only a short time. Dogs do like to be able to see you, however. If you turn a corner, almost all dogs will immediately move forward to find you again.

9. "Gentle"

A dog must be taught not to snap at food, though its instincts tell it to grab things before another dog gets it. You must never tease a dog with food—it will learn to snap at it and someone will be hurt. Always present food firmly on a flat palm. If the dog lunges at it, say the word "Gentle!" in a firm, low voice. It will hear the tone and hesitate.

10. Begging

I'm not really sure if this is a trick or not. Small dogs do this almost automatically. If you hold a biscuit slightly out of reach of a terrier, it will probably sit back on its haunches rather than leap for it. Collies are almost all hopeless at begging and fall over when they try. If you do want to try teaching it, the same requirement of treats, patience, and common sense applies. Have the dog sit and hold the treat just out of reach. If you have taught it the command word "Gentle!" this could be used to stop it from snapping at your fingers. Let it have the first treat just by stretching, then move the next a little higher so its front paws have to leave the ground. Repeat for months.

11. *"Drop!"*

This is a very important command. Puppies in particular are very playful and as soon as you touch something they are holding, they will pull back and enjoy the game as you desperately try to save your shoes from destruction. It's best to take them by the collar to prevent them from tugging too hard and say "Drop!" in a loud, fierce voice. Repetition, as with all of these, is crucial.

12. "Over! Over!"

Different families will have different command words, of course. This one is probably not that common. Our dogs are always taught to jump at hearing this. You may be out walking and need them to jump a low fence, for example, or jump up onto a table to be brushed. Begin with a higher surface and simply pat it firmly, saying "Over! Over!" to it in an excited voice. If this doesn't work, do not pull it up by the collar. It could be frightened of being off the ground and that won't help. If you can, lift it to the higher level and then make a huge fuss over it, giving a treat. Repeat pats and lifts until it is comfortable with the higher position.

This is quite funny to see. Like cats, dogs can really jump, but they aren't taught to do it on command very often.

13. Toilet Command

Police dogs are taught to evacuate their bowels and bladder on command. It's done by using the command word— make your own one up—at the time when the dog is going to the toilet, and then the usual routine of making a fuss and giving a

treat. In all honesty, this is only useful when, say, a dog will spend most of the day inside an airport and must not pee on luggage. For pets, it isn't worth it.

14. Jumping Through Your Arms

Not all dogs can do this—the terrier absolutely refused point-blank. The command "Over! Over!" is useful, as the dog knows it is for jumping. Begin by making a circle on the floor with your arms and having the dog called through for a treat. You need

two people for this. After a few successful repetitions, raise your hands from the floor, so the dog has to step up a little to pass through. It's probably far too excited by then, so try this again the next day. Raise your hands higher and higher, then stand upright, holding your arms out in the largest circle you can make. Dogs the size of collies can do this, though some will thump you in the body or hit your hands as they go through. They improve with practice and it is a great trick used to impress other dog owners.

15. Finally, Attack Commands

There is no secret to having an attack word for a dog. Be aware, however, that unless it was absolutely justified, the dog is likely to be destroyed. Children accompanied by dogs are much less likely to be troubled by strangers, regardless of the breed of dog. Dogs are known to be aggressive and territorial, especially with strangers—men in particular. They do not need to be taught higher levels of aggression.

The opposite of this is what to do if you come into contact with an aggressive dog. First of all, it is a risk to put your hand out to pat any strange dog. If you

must take the chance, let the dog smell your hands first, coming in slowly and low down so as not to startle it. If it show its teeth, move away. Mankind is the only animal on the planet who shows his teeth to smile. The rest of them are saying "Go away or I will attack." The same applies for growling. It is never playful. Never growl back. That is what another dog would do and the aggression will increase dramatically. Most dogs have the courtesy to warn you. Take the warning and back away.

If the dog does attack, remain on your feet and protect your face. Don't scream. Break eye contact if you can, as dogs see a direct gaze as aggressive. Dogs are almost never interested in serious damage. They simply want you to go away. Do not run, however. Walk away slowly. Big dogs like Alsatians may hit you hard in the chest or back to try to knock you down. Being on the ground is not a good place to be during a full attack.

If you do end up on the ground, curl up to protect your face and neck. Again, they will do a lot more barking than actual biting in almost every case. Remain as still as you can and don't call for help or scream. The noise may excite them.

A well-trained dog will not be aggressive with

other dogs or people. They will guard your home, force you to remain active by walking them, play with you whenever you have the slightest interest, and adore you with complete trust in any weather, on any day.

BOTTLE ROCKET

You will need:

- A large plastic bottle
- A wine cork
- A drill and drill bit
- A bicycle inner tube complete with valve
- A bicycle or car air pump

THIS IS SURPRISINGLY good fun to make on a summer's day in the garden. First cut the valve off an inner tube, leaving a small circle of rubber as you see on the next page. Next, drill a hole through the length of the wine cork. Ask an adult to do this for you. The cork must be held in a vise and this isn't easy. Drill a hole that is barely big enough for the valve. When that is done, push the valve through until it shows through the other end. It might help to dribble a little oil in the hole first.

There must also be enough valve sticking out to attach the pump. If there isn't, take it out and cut a bit off the cork.

In trying this, the top of our plastic bottle was too wide for a normal wine cork. We ended up sanding and cutting an old champagne cork to fit, so it's probably worth your while getting one ready, or making sure you have a bottle into which a wine cork does fit.

Fill the plastic bottle about a third full of water, then jam the cork in as hard as you can into the open top.

For this to get airborne, you're going to need some sort of launching pad. We had some old bricks lying around, which worked very well. It helped to have a brick on each side of the bottle to steady it.

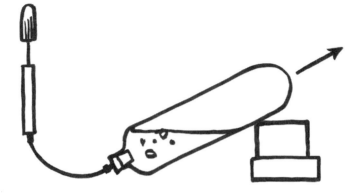

Attach the bicycle or car pump to the valve and pump vigorously until the pressure builds up enough to send the bottle into the air.

You should get a height of at least 20 ft (7 m). If it goes off too early, the cork isn't in tight enough, so reshape it by rubbing it on sandpaper and jamming it in again.

This works because it uses the same principles as a NASA space launch. If you throw out material in one direction (water in this case) the object will move in the opposite direction. Newton's third law of motion: "Every action has an equal and opposite reaction" works as well in a garden as it does in space.

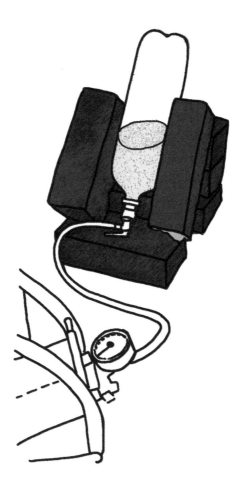

PAPIER-MACHÉ

PAPIER-MACHÉ IS FRENCH for "chewed paper." It is something every boy should try to make at one time or other. It's incredibly simple stuff, but you can make just about anything out of papier-maché if you have the right mold.

> You will need:
>
> - Old newspapers
> - Wallpaper paste/flour and water mixed to make a thin paste
> - Petroleum jelly
> - Water-based paints
> - Cardboard, or a balloon, or an egg depending on what you're making

Making the Head of a Person

Making the body for your guy is just a matter of stuffing old sweaters and trousers with scrunched up newspaper. Making the head takes a little more time. Start with a balloon and a pile of torn newspapers. Mix up your flour and water paste or, if you're using wallpaper paste, mix it according to the instructions on the box. Have a good supply ready in a big saucepan or bucket.

First, inflate the balloon and then apply petroleum jelly all over its surface so it will come out easily later on. Then dip strips of paper in the paste and place them on the balloon, overlapping and smoothing down as you go. Leave a small gap near the knot on the balloon so you can pop it later. For a solid head, you are going to need five or six complete layers. We found it was a good idea to complete three layers, allow it to dry overnight, and then complete it the next day. The paste in the bucket doesn't dry out that quickly and can just be left as is.

When the layered head is completely dry, use a pin or bite a tiny hole in the rubber near the knot to let the balloon deflate. You will end up with just a shell. Mark out eyes, a nose, and a mouth with a felt pen, then color the rest with any water-based paint. You

will end up with a very pink, bald guy with quite a surprised expression. It's worth cutting a piece of dark cloth into strips to give him some hair, or alternatively gluing on lengths of string. Use strong sticky tape to attach the head to the rest of the body.

One variation on this is covering only the top half of the balloon to make a soldier's helmet, which can be painted green. You can also create face masks in the same way.

Making a Boat

Now that you have the basic idea, you might think of making a boat. Take a cardboard box and cut shapes to make the sides, a bottom, and a deck as your molds. You can make the main shape, then add the deck later. It helps if you support the deck with a piece of sponge that you can leave in place as it dries.

Take time in creating a good-looking boat shape. A flat bottom will give stability. For that, cut a narrow strip of cardboard shaped like a fish—fatter in the middle than at the ends. If you want to have a sail when it's finished, cut a hole in the deck and put a thin wooden dowel rod through it, pasting a cone around the base to hold it in place.

Prepare your paste and paper as before. This time, you will use the strips to bind the cardboard pieces together as well as covering them. With the cardboard remaining inside, you won't need more than three layers to have a strong structure.

When it is dry, you'll need waterproof paint, the kind that is used on the exterior of houses. It's a good idea to check to see if you have some of this already before you start, as it is expensive stuff. It's also murder to get out of clothing, so wear old clothes and have some paint thinner on hand to get it off your skin. Do the painting with your dad. He'll go on about the navy and will have to come with you when you launch it but at least it will float.

When the paint is dry, take a triangular piece of cloth and use strong thread to tie two corners to the mast and the third to the prow—the pointy end—of your boat. Launch it on a lake on a windy day, where there is a reasonable chance it will make it to the other side and not get stuck in the middle.

Egg Mobile

As you can see, the only limit on using papier-maché for making objects is having some sort of frame. Cardboard is excellent for uneven shapes, but you might also try making a mobile out of eggs in the following way.

First use sandpaper to open a small hole in each end of an egg. Force the contents out into a bowl by pressing your mouth to one end and blowing. It's a good idea to have scrambled eggs afterward rather than waste the insides of the egg. Just add milk, a pinch of salt and pepper, then stir as it gets hot. As always with cooking, it's sensible to have an adult nearby and the fire department on alert.

When the shells are empty, glue cardboard fins to them, then cover all of them in small strips and paste, just as you did with the balloon head. Paint as before and pierce a small hole in one fin to allow you to suspend the fish. A mobile is just a collection of these in various colors, hanging from a crosspiece of two dowel rods or coat hanger wires.

MAKING A GO-CART

THE HARDEST PART of making a go-cart is finding the wheels. The sad truth is that most modern baby carriages have tiny wheels, so the classic idea of finding one and removing its axles intact isn't really possible anymore. Those carriages that do survive are antiques and too valuable for our purposes.

THE DESIGN

You will need

- Two fixed axles with wheels attached
- Plank to sit on—we used ¾ in (18 mm) pine
- Axle wood. Length will depend on your axles, but we used a plank of 3½ × 1½ inches (88 mm × 37 mm)
- Rope for the handle
- Two eye screws to attach the rope
- Four electrician's metal "saddles" (see explanation below)
- Wood paint (color of your choice)
- 1½ inch screws (40 mm)
- Vinyl and foam if you intend to add a seat
- A steering bolt (see explanation)
- Upholstery tacks for the seat

First, cut the wood. We cut two lengths of 17 in (43 cm) for the axles but this will be different for each project. We also cut quite a long central plank at 3 ft 9 in (114 cm). Again, that depends on the length of

your legs. Allow some growing room at least. It really is a good idea to let your dad cut the wood for you, especially if power tools are involved. If you ignore this advice and cut off a finger, please do not send it to us in the mail as proof.

However, the good news is that there are other things you can use. We found our two axles after many visits to three local waste maintenance centers—dumps. It took many weeks to find ours, so the best you can do is to go out now and make your face known to the employees of every dump, recycling center, or junkyard in your town. Our rear axle came from a golf cart and our front from a modern three-wheel stroller—used ones are just starting to appear in these dumps, so you might find one faster than we did. The other possibility was to find a tricycle and use the rear wheels. As long as it has a fixed axle that doesn't turn with the wheels, you needn't worry. If at all possible, use metal wheels rather than plastic ones. Plastic is an awful material and has a tendency to shatter under stress—while going down a hill, for example.

It is also a good idea to sand and paint the wood—or varnish it—at this stage. We completely forgot to do this and painting it at a late stage was very

difficult. Better to do it now. We used a wood primer and black matt paint. As we had an old can of varnish in the shed, we then varnished it as well. You can, of course, buy paint, but digging out old cans with just a dab still wet at the bottom is somehow more satisfying.

When the painted wood is dry, attach the axles. Twenty years ago, we used U-shaped nails, and these were perfectly reliable. This time we found our axles were much wider and had to find an alternative. This is the sort of problem you might have to solve.

Above is an electrical "saddle," available for a few dollars from any electrical store. They are also quite useful for attaching axles and come in a variety of sizes.

We used three saddles on the front axle. The original plan was for two, but one of the screw holes seemed weak and we wanted it to be reliable. Make sure you place the saddles carefully so that the axle is straight on the plank. Given identical saddles, we measured the distance from the top of each one to the edge of the wood. You can place this by eye, but it's better to measure and be certain.

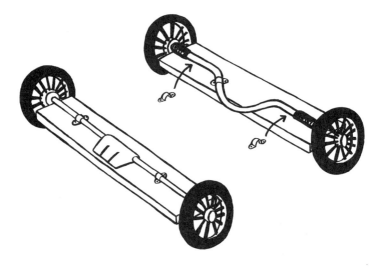

1½-in (40 mm) screws will secure the rear of the main plank, as shown on the next page. It looks easy, but some careful measuring is necessary to make the angle between the main plank and the axle plank exactly ninety degrees. You must also make sure that the overhang on each side is the same. We clamped the pieces together quite loosely and then used a rubber mallet to tap it into place, measuring again and again until we were satisfied.

The steering mechanism is the only tricky thing left to do. We were extraordinarily lucky in finding that the single-wheel bolt on a three-wheel stroller is perfect for this, but you can't depend on that kind of luck. You must find a bolt with a thread only partway down.

Bolt from a three-wheel stroller

More likely to use this one

The benefit of this is that a nut can be tightened on the bolt and yet the bolt can still turn freely in the hole. They are available from any hardware store. Find one a little over the length you need and add a washer at both ends—or more if it's too long.

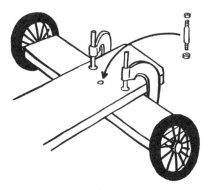

MAKING A GO-CART

Getting the front position right wasn't as hard as the rear. It was crucial to have the same distance of axle poking out on either side as before, but it didn't have to be at ninety degrees, as the axle was going to pivot—otherwise there could be no steering. The nice thing about this design is that you can sit with your feet on the steering bar, also holding onto ropes. As a result, it is extremely maneuverable.

We decided to put a seat on ours. We asked in a carpet store and were given a piece of carpet and a vinyl sample for free. We folded the vinyl around a piece of pine, using the carpet as padding between. We then tacked it down with upholstery nails from a hardware store and screwed the whole thing to the main plank from underneath. The rope was attached using a bowline knot on each end.

Cost

Getting a stroller and a golf cart from two different dumps cost us two ten dollar bills. We think it might have been possible to get them for less, but after weeks of asking, we were so pleased to find them that we offered too much. Begin by offering five

dollars. The wood came to $20, the screws, nuts, and washers cost around another $10. The paint came from old cans in the shed. We already had the rope. Altogether, it came to around $60. However, to buy a go-cart of this quality, you would have to pay at least $100 and possibly even $150 or more. This one has the benefit of lasting longer than pedal versions (room to grow), being much faster down hills and, well, being something you made yourself rather than from a company in China.

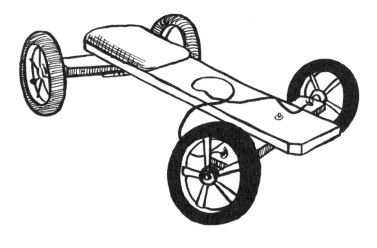

MAKING A BATTERY

A BATTERY AT ITS SIMPLEST is a cathode (the positive end), an anode (the negative end), and an electrolyte (the part in the middle). There are quite a few different combinations out there. Electricity is the movement of electrons, tiny negatively charged particles. The anode tends to be made of a substance that gives up electrons easily—like zinc, which gives up two electrons per zinc atom. The cathode tends to be made of substances that accept electrons easily, like copper.

The electrolyte inside can be a liquid, a gel, or a paste. All that matters is that it contains positive and negatively charged ions that flow when the anode and cathode are activated. When the Italian physicist Alessandro Volta made the first battery, he used copper for the cathode, zinc for the anode, and an electrolyte of blotting paper and seawater. His name gives us the word "volt," as in a 12-volt car battery. If you think of electricity as a water pipe, a volt would

be the speed of the water, but it also needs a big hole to flow through—or "amps." You can have enough voltage to make your hair stand on end, but without amps, it won't do more than cause a tiny spark. A house supply, however, has 240 volts and enough amps to kill you as dead as a doornail.

You will need

- Ten quarters
- Metal kitchen foil
- Blotting paper
- Two pieces of copper wire (taken from any electrical wire or flex)
- Cider vinegar
- Salt
- Bowl
- LED—a light emitting diode (available from model and hardware shops)
- Masking tape

We'll use the quarters as the cathode and the foil as the anode.

Cut the foil and blotting paper into circles so they can be stacked on top of one another. The blotting paper will be soaked in the vinegar, but it is also there to prevent the metals from touching—so cut those paper circles a little larger than the foil or coins.

1. Mix vinegar and a little salt together in the bowl. Vinegar is acetic acid and all acids can be used as an electrolyte. Sulphuric acid is found in car batteries, but don't fool around with something that powerful. It eats clothing and can burn skin.

 Common salt is sodium chloride, a combination of a positive and negative ion ($Na+$ and $Cl-$). These will separate in the electrolyte, increasing its strength.

2. Soak your circles of blotting paper in the ion-rich electrolyte.

3. With the masking tape, attach the end of one wire to the underneath part of a foil disc. This is the negative terminal. Now stack the discs in this sequence—foil, paper, coin, foil, paper, coin. Each combination is its own tiny battery—but to light even an LED (light-emitting diode) you'll need quite a few. A car battery tends to have six of these, but with a much larger surface area for each "cell." As a general rule, the bigger a battery is, the more power it has. (Power measured in Watts = amps × volts.)

All the positive ions will go to one terminal, all the negative ions to the other. In effect, you are charging your battery.

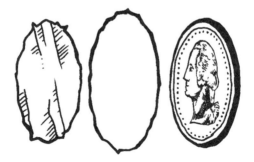

4. When you have a stack, you can attach a wire to the last coin with tape. This will be the positive terminal. Then attach a wire to the first foil disc. This will be the negative terminal. They can now light an LED, as in the picture below, or with enough coin batteries, even a small bulb.

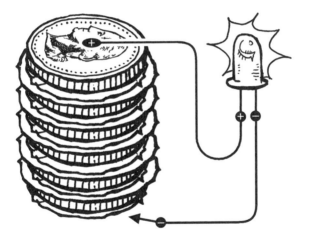

There may come a time when batteries go on to a new generation, but if you can understand the battery you have just made, you can understand every type of battery currently available, from nickel-cadmium to lithium-ion, from rechargeable phone batteries to the ones that drive toy rabbits. You won't hear acid sloshing in alkaline batteries, where a paste or gel is used, but the principles are identical.

CONKERS

T HE FIRST THING TO DO is spend an autumn afternoon throwing sticks into the branches of horse chestnut trees. For conkers, the bigger the better is a good rule and any that still have white spots should be given to friends—they are useless. Collect more than you need. This is only your practice year. Next year, you'll take out all the ones you prepared and win constantly, but this is the year you learn your skills.

The trickiest part is making a neat, small hole. You will be tempted to use a nail, a spike, or anything else with a point. This does work, but there's always a chance of spoiling a good conker in the process. Better to get your dad to use a drill on them. Don't try that one yourself. The conkers spin around at high speed, or crack when you put them in the vice. Much better to ask your dad to do it, but give him your worst conkers to start with until he has learned the knack.

Once you have your holes, you need a strong shoelace. Don't waste time with the ones from dress shoes—they just cut into the conker.

Getting the lace through is always tricky and takes patience. Start by licking the end and twisting it into the hole, pushing and twisting to feed it in. Once you have it started, you'll need a piece of stiff wire to poke it through. Don't be tempted to use a fork, they never worked for us. Prod and twist until you can see the other end and then tweak it through with the wire. It's a good moment when you can finally pull the whole length through.

You'll need a big knot to keep it from slipping back into the conker. The classic is the simple overhand knot, but you'll need three or four of them to be sure of avoiding catastrophic slippage. (Loop it over itself and then put the end back through the hole. Everyone knows this one and it's too basic to put in the chapter on knots.)

Now you should have a conker that looks a little like the one on the the next page.

Yours will be round and shiny whereas this one is like a piece of wood, but that's because this is a year old and has been hardened using the techniques at the end of this chapter.

If you can find a lot of old laces, you might think of taking ten or twenty conkers to school and selling them for 20 or 50 cents each. The aim is not to make money, but to create an instant conker club one lunchtime. You are going to need people to beat, after all.

NOTE: Sell them ALL before you start playing. People won't enjoy losing to you and then having to buy another conker from the same person.

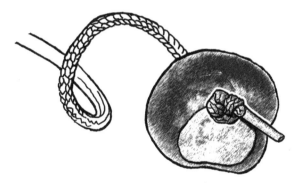

The Rules

1. Choose who goes first by tossing a coin. Wrap the conker securely around your hand. If it flies away on the string when someone hits it, the rule of "Stompies" comes into play. Anyone, including teachers, can stamp it flat and laugh in a menacing fashion.

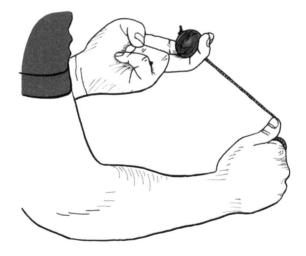

2. When it is your turn to strike, keep the string tight with two fingers under the conker. Smack your opponent's conker as hard as you can.

3. When you're being hit, let it dangle a little less than the length of your forearm. Any shorter will be too easy to send into a windmill. (See Rule 4.)

4. Windmills. If your conker is sent in a complete circle, your opponent gets another go. Whether this rule is applied or not is agreed upon before starting the game.

5. Strings. If the strings become entangled by a bad shot, the person on strike loses his turn.

6. Take shots in turns until one conker is destroyed.

Scoring

There is an element of trust here, but if you win one contest, you now have a "one-er." If you win another, you have a "two-er" and so on.

If a "three-er" beats a "two-er," you add the numbers together to make a "five-er." That conker is now responsible for the deaths of five conkers in battle. Do not lie about this. Honor is at stake.

How to Prepare Your Conker

The best conkers are the ones you left in a cupboard the year before. If you do this, remember to make the holes first, as it's practically impossible when they're rock hard. By all means, play the first year— but at the same time, prepare for the next by securing a supply.

Apart from the passage of time, the classic methods of conker hardening are:

1. Soak in vinegar for an hour, then bake in an oven at 475 °C for five to ten minutes. All you're trying to do is speed up the effect of drying out for a year, so don't leave them to roast and go black. It's best to let your parents do the oven part as well.

2. This one probably steps over the line of clever competition preparation into outright cheating, but a single coat of varnish is difficult to detect and helps to hold the conker together. Do not try more than one coat, as a conker that looks like a golf ball will be noticeable.

Avoid trying to fill the conker with something hard, like glue or fiberglass resin. At some point, the conker

will break open and reveal what you have been up to. Bear in mind that suspicious opponents may want to check your conker. It's best to play "clean" and be honest.

Now go out and find a big stick.

MAKING CANDLES

—※—

WHEN WE WERE BOYS, our parents kept a box of white candles in a kitchen cupboard. Anything involving fire was fascinating in those days and we felt such treasures should not be left for something as unimportant as a power outage.

The plan was to melt the white ones in an empty dog food can, then to sell the new, huge candle to someone who had everything in life except a huge candle.

The melting part went well and we put a wick in the dog food can as we poured the hot wax. Our mistake was putting the can on the living-room carpet. When the wax had cooled and we lifted the can, a perfect circle of carpet came up as well.

Bearing that childhood disaster in mind, please remember that making candles involves a stove top and hot liquids. This is definitely one to do with an adult.

You will need

- A supply of wax. Some hobby shops sell waxbeads for candle making or, if you can't get those, a couple of white pillar candles will do the trick. Yours will be better.
- A kitchen saucepan, three-quarters full of water
- A long, narrow vessel of some kind. In researching this chapter, we used a metal cocktail shaker, but most kitchens will have something suitable.
- String—not made of plastic, as no one likes the smell of burning plastic
- Wax crayons, to color the candles
- Newspapers to protect the kitchen

First, place the container you have found into the saucepan of water. Then break up the pillar candles into chunks, removing the wicks. If you have wax-beads, simply pour them into the container as it sits in the water. Turn the gas or electricity on high and wait until the wax has dissolved into a clear liquid. It will go faster if you put a lid on the saucepan.

When the last lump has dissolved, turn down the heat to keep the water at a very gentle simmer. The wax will be hot so be careful not to spill it.

Add whatever color crayons you want the final candle to be. We tried red and blue together to make purple. Stir the mixture with something you don't mind getting covered in wax.

Cut four or five pieces of string, about twice the length of your container. You can always snip off any extra wick once it's cool. Lay out the newspapers nearby, bearing in mind that you do not want them to catch fire. Some dripping is inevitable, so plan your workspace to keep it to a minimum.

Dip the lengths of string in the wax one at a time and then lay them out straight on the newspaper to dry. Don't worry if there is a bend—the candles stay pliable for ages and you can always correct it later.

The trick is getting the right dipping speed. If you

are too slow, the wax already on the string will melt off again. Too fast and it won't have a chance to form a new skin.

It's useful to have more than one person doing this, so you can keep a rotation of four or five of them going at the same time. Don't worry if the candle bulges in the middle—it will get better.

If it's taking too long, turn off the heat. The liquid wax will take about an hour to solidify and that's plenty of time to make a few thick candles. This is quite a tedious process, but it's interesting to see the candles form, layer after layer. Make them as thick as you like and if the wax starts to grow cold, leave them on the newspaper while you heat it up again.

When you have the width you want, press the end onto a surface so that it becomes flat enough to stand on its own, then tie a loop in the string and hang it from something to cool completely.

If you want to save the wax for another attempt later—or to thicken the candles you have made, pour it into a clean cardboard carton that can be torn apart.

Food coloring doesn't mix with wax, so don't try adding it. Water-based kitchen essences will just evaporate. If you want it to smell nice as it burns, you need to add an aromatic oil, available from pharmacies.

As kids, we probably wouldn't have managed to sell the candles we made, even if they hadn't ruined the carpet and been thrown away by an irate mother. Still, there's satisfaction in making anything, and in acquiring any new skill.

MAKING CANDLES

MARBLES

---✦---

THE ROMANS played marbles. They were made from stone, clay, or marble (aha!), though marble marbles were the most accurate. These days, glass and china marbles are still available in most toy stores. Do not be deceived: the version of marbles called Ring Taw can be frustrating and demanding— but it is the best. All you need is a flat surface, a piece of chalk, a bag of marbles—and a competitive streak.

We thought about trying to make a couple of marbles, but the temperatures involved would have meant you're reading something called *The Suicidal Book for Boys*. Molten glass has differently colored glass injected into it before being cut into cylinders and dropped into a rolling tray where the marble rolls itself to perfection.

Marble Names

Any marble you use to take a shot is called a **Shooter**, or a **Taw**. For the rest, there are as many names as there are types of marble. Some of the better-known examples are: Pee Wees, Boulders, Chinas, and Normals.

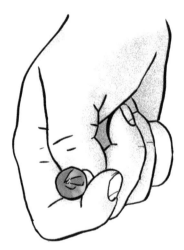

Fulking

Fulking is the name of the classic schoolboy technique for shooting. The hand remains in the air during the shot.

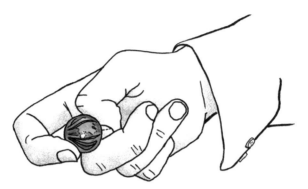

The professionals, however, (and they do exist) use "**knuckling down**," where the knuckles must touch the ground during the shot. From this action comes the phrase "to knuckle down" to something. It is almost the same action, though greater accuracy is possible with that steering finger. However we preferred the one we remembered from school. With fulking, there's a danger of letting the marble fall out and roll across the circles, which can be embarrassing. This can also lose you the game.

The Three Games You Need to Know

Ring Taw (or Ringer)

1. Draw two circles in chalk, as you see below. The small one is 12 inches across, or a ruler's length (30 cm). The larger one is 6 feet (1.83 m) across. Remember that the distance from your elbow to your wrist is roughly a foot (unless you are tiny, obviously). Otherwise, find someone who is 6 feet tall and ask him to mark out the circle using the distance between his outstretched arms, which will also be 6 feet.

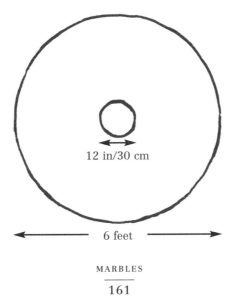

12 in/30 cm

◄——————— 6 feet ———————►

2. Choose which marbles will be risked from each bag—equal numbers from each player. This is a skill game—it doesn't matter which ones you lose or win, just how many. Put them in the inner circle. We found tactical placing of one at a time worked well, taking turns.

3. The Taw can never be lost. It can be a personal favorite, a rare one, metal, marble, china, glass, or even wood. Practice with your Taw and never allow it to be a stake in the game.

4. Decide who is going first.

5. First shot. The aim is to shoot the Taw from any point on the outer ring at the ones in the center. Any marbles knocked out of the inner circle are pocketed by the shooter, who then takes a second try, unless the Taw has vanished inexplicably. If you can find it, shoot from where it lies.

6. If you miss, or fail to knock one out of the inner circle, play passes to the next player. If your Taw stops in the outer circle, it stays where it is for Rule 7. If it stops in the inner circle, it must be

bought out with a replacement marble from the offending player.

7. When a Taw is stuck in the outer circle, it becomes a target. The next player can choose to try for the center or the Taw. If he hits the Taw, he has to be given a marble by the owner. He may not strike it twice. If his Taw gets stuck, the game moves on.

8. The game continues until the inner circle is clear.

Bounce About

This game is a throwing rather than shooting game—the marbles are in the air during the shot. Bigger marbles are better for this game.

1. The first player throws his marble forward about 5 feet.

2. The second player does the same, trying to hit the first marble. (Other players can hit either and so on. This can be played by quite a number.)

3. All shots are underhand and taken from where the Shooter lands.

4. If a marble is hit, the owner either loses it or pays a marble penalty from the bag. It's better to pay the penalty so as not to lose your Taw.

That's it. All the tactics come from the game.

Hundreds
This is a surprisingly addictive accuracy game for two players.

1. Draw a small chalk circle—diameter 12 inches (30cm).

2. Both players shoot a marble at the circle from an agreed distance.

3. Both in or both out earns nothing.

4. One in the circle earns ten points and another try.

5. First to a hundred wins.

Fouls

1. In Ring Taw, the shooter's knuckle must touch the outer circle. Lifting is a foul.

2. "Fudging" is pushing the hand forward—and a foul. The marble must be shot with the thumb alone.

3. After the game has begun, no contact with marbles in the inner circle is allowed, except by the Taw.

The world championship is played every year in Tinsley Green, West Sussex, England. In essence, it is Ring Taw, with forty-nine marbles in the inner ring, worth a point each. The winner is the first to knock out twenty-five with the Taw.

Playing marbles is not about how many marbles you can buy, it's about the ones you win and lose—it's about skill and your Taw.

GROWING SUNFLOWERS

THIS IS SUCH A SIMPLE THING, but it can be fulfilling and if we didn't mention it here, a chance could be missed. These plants (*Helianthus*) are called sunflowers because they turn toward the sun and, when mature, their large round heads resemble the sun. In French, they are called "tournesol" and in Italian "girasole." You can find sunflower seeds in hamster food or a health-food shop. Growing any plants and flowers can be rewarding, but sunflower seeds are particularly good, as sowing to blooming takes only sixty days of a good summer. They grow at an unusually high speed with impressive results.

Plant the seeds in fertile soil in late spring. All you have to do is get hold of some of the black-and-white-striped seeds, put them in a little earth in a plastic cup, add water, and wait a few days. They need sunlight, so make sure the cup is on a well-lit window ledge.

GROWING SUNFLOWERS

The seeds split open and rise on the stalks looking like hats. Remove the seeds when you can see the leaves.

Eventually, you may have to use thin wooden stakes to support the stems. These plants will produce one of the largest flowers you can grow anywhere, with a headful of edible seeds. The final height can reach 8 feet (2.4 m)!

The picture shows the plant after a month, almost 2 feet (60 cm) high. They have been repotted, which just means adding a little extra earth or compost and a good watering. If you have a spot that receives regular sunshine, they will thrive in open ground—but check them for slugs and snails at regular intervals. To sustain this sort of growth speed, they do need water—so don't forget to give them a daily splash.

When the flowers finally fade in late summer, break apart the heads with your thumbs and you will find hundreds of the striped seeds ready to start new plants again next year. The shells contain a pleasant-tasting inner seed that can be eaten raw. You might also try roasting the shells until they brown, then serving them with salt and butter. They are a good source of potassium, phosphorus, iron, and calcium.

CATAPULTS

—⟡—

CATAPULTS HAVE INTRIGUED boys for as long as they have had access to strips of rubber. Before then, slingshots of leather were used right back to biblical times, as when David slew Goliath by hitting him in the forehead with a stone. They do have a serious use in hunting, of course, or for launching bait into a river while fishing. However, the classic images are more to do with Dennis the Menace and Bart Simpson. Catapults can be astonishingly powerful and accurate, though this is not something to demonstrate by telling a younger brother "Run" and laughing in an unpleasant fashion. Never aim or fire a catapult at someone else.

You will need:

- A forked stick
- A piece of rubber—2 ft (60 cm) long
- Twine to tie the ends
- A piece of leather, such as the tongue from an old shoe

1. Find and cut a forked stick. We found our example in a large holly bush, but the "Y" shape can come from almost anywhere.

 A Swiss army knife has a saw attachment that makes short work of small branches. You don't want the diameter of the wood to be any thicker than your thumb. If you are not confident in your "eye," cut a little more than you think you will need. A good top to bottom height is 6 or 7 inches (15–17 cm).

2. Cut rings from the bark at the top of the "Y" to anchor the rubber—a Swiss army knife is perfect for this, too.

3. Finding the rubber is the hardest part. After a fruitless search in hardware and toy stores, we found that a strip cut from a bicycle inner tube works very well. Cut a 2-foot length of tube and then make two cuts lengthwise to remove a long strip. Some experimentation will be necessary to get the right pull tension and power.

 Note that we have used two pieces of rubber. It was tempting to use one long piece, with the central pouch threaded through. In practice, we

found that the pouch piece moved after one or two shots and suddenly we had a catapult that could fire almost anywhere without warning. It is far better to tie two pieces securely.

4. The central pouch piece is easy enough to make if you have an old shoe. Either the tongue of the shoe or some part of its body can be cut to produce a rectangle of material around 4×2 inches (10×5 cm). Leather is best for this, as it can be punctured without splitting. Make two holes with a sharp point and attach the ends of the rubber. You now have a catapult.

HOW TO PLAY POKER

EVERY BOY should know how to play this game—but be warned, luck has very little to do with it. High rollers in Las Vegas stay clear of poker because playing against experts is a humiliating way of giving money to strangers. In many cases, the roulette wheel is more attractive to those people—at least when they are thrown out of the casino wearing nothing more than their underpants, they have only themselves to blame.

There are dozens of variations of poker, so we're going to cover only two popular games: Five-Card Draw and Texas Hold'Em. It is worth mentioning at this point that poker is a game that must be played for money. There is no *risk* in throwing all your matchsticks into the pot—and therefore no chance to bluff. It is possible to limit the bets to a level where it doesn't mean you have to sell the dog, but you can still feel as if you've won something.

Five-Card Draw

The aim is to beat the other players and that can be done by sudden changes in betting, bluffing, or simply having a better hand. The very first thing to learn is the value of hands. Here they are, in order:

The best hand possible is the **royal flush**—all cards in sequence, from ace to 10, and of the same suit. The odds against being dealt this hand are 650,000/1. It would be a lifetime event to see one of these in the first five cards. Below that is a **straight flush**—again, all the cards in sequence and of the same suit, but lower down the line: 4, 5, 6, 7, 8 in spades, for example. Even that has odds of 72,000/1.

Four of a kind. Odds against being dealt it: 4,000/1.

Full house. Three of a kind and a pair. Into the realms of possibility, perhaps, at 700/1.

Flush. All cards of the same suit but of mixed ranks. Odds: 500/1.

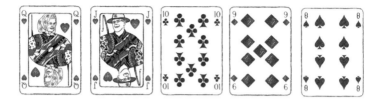

Straight. All five cards in sequence, but of different suits. 2, 3, 4, 5, 6, for example, or the high one seen in the picture. Odds: 250/1.

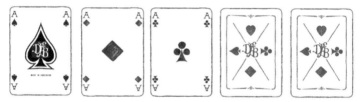

Three of a kind. Three cards of the same rank. Odds: 50/1.

Two pairs. Odds: 20/1.

One pair. Odds: 2.5/1.

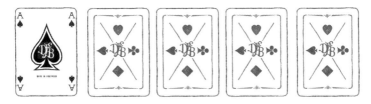

High card or no pair. Odds: 2/1.

Memorize these rankings and what they mean. You really can't check them while playing.

Four players is the classic home-game number, but five or even six can be accommodated.

Begin by placing an agreed amount in the pot. This is to prevent weak hands being automatically folded. If one player does nothing but hold on, he may scoop up the pot—and that should be worth something.

A dealer is nominated to start. Whoever is dealer will go clockwise around the table. It is common practice for the dealer to shuffle the cards, then slap the shuffled pack onto the table for the person on his right to cut.

When the dealer is ready, he deals five cards face down to each player. These are examined without showing them to anyone.

A round of betting follows. Betting also goes in a clockwise direction, so the person to the left of the dealer puts an amount of money into the pot. For the sake of the example, we'll say the bet is ten cents.

Going around the circle, each player now has three choices.

1. They can pay ten cents to stay in, saying "I'll see that ten." The word "call" is also used.
2. They can raise the bet, saying "I'll see that ten and raise you another ten."

3. They can fold their cards, saying "Fold," and drop out of the hand.

The person opening the betting has a further choice of saying "Check," meaning "No bet." It could be a bluff, or it could be a weak hand. Other players can also say "Check" in response, but if someone puts money in, everyone has to match it or fold.

If the ten-cent bets go around the table, the betting round ends. It cannot be raised by the first better.

If someone *does* raise it, saying "I'll see that ten cents and raise you another ten," they are showing their confidence in their hand. To stay in now, everyone else will have to match the combined bet of twenty cents.

When the round of betting is over, the dealer offers the person to his left the chance to exchange up to three cards. If the player already has an excellent hand, he might refuse the offer. Most players will exchange, though, keeping the pair of sevens they were dealt and hoping to be given another one.

If you are thinking that mathematics is your weakness, you really should not be considering playing poker for money. Give it to charity instead—it will be put to better use than ending up as someone else's pocket money.

A FEW USEFUL IMPROVEMENT ODDS

- Three of a kind, change two cards:
 odds on four of a kind or full house 9/1
- Three of a kind, change one card: odds
 on four of a kind or full house 12/1
- One pair, change three cards:
 odds to improve to two pairs 6/1
- One pair, change three cards:
 odds to improve to three of a kind 9/1
- One pair, change three cards:
 odds to improve to a full house 98/1

There are dozens more—and the good players know them all.

Another calculation that comes in is whether winning a particular pot is worth the bet.

$$\frac{\text{size of pot} \times \text{"probability of winning"}}{\text{potential loss}} = \text{investment odds}$$

If the answer comes to more than one, it's probably a good bet to make—but note the fact that "probability of winning" is expressed as a fraction and could be guesswork.

$$(50 \text{ cents} \times 0.4) / 10 \text{ cents} = 2.0 = \text{good bet}$$

The final aspect of poker is the ability to read other people—not just their expressions, though this is the game that created the phrase "poker face"—someone who hides their emotions. Patterns of betting can also be read. Perhaps when you sit with Jim you notice that whenever he has a good hand, he puts in a very big bet at the first opportunity. You might avoid hands when he does this, but there is always a chance he is deliberately setting up a pattern on good hands, to then do it on a bad hand and watch everyone else fold . . . that's bluffing.

In essence, that's about it for draw poker, except for invaluable experience. The chances of good hands are increased by "wild" cards. If you get these in a hand, you can call them anything you like, which throws the odds right out of the window. Suddenly, unheard-of hands become possible, like five aces.

Texas Hold'em

This is the type of poker played at the world championships. First, the two players to the dealer's left put up "the small blind" and the "blind"—usually half the minimum bet and the entire bet. This becomes more significant as the game goes on and bet limits increase.

Two cards are dealt face down to each player. These are the "hole cards."

A round of betting takes place, exactly as described above, with raises, folds, etc. It is customary to say "Call" when matching the current bet without a raise.

When betting comes to an end, the dealer deals the "Flop"—three more cards, this time face up where everyone can see them.

After the Flop, another round of betting takes place, beginning with the player to the left of the dealer. He has the choice to bet, fold, or check, as with the Five-Card Draw. If he checks and the next person bets, he will have to match it—but will now have a better idea of the sort of hands held. As a result, checking can be tactically useful.

The dealer plays another card face up, the "Turn,"

beginning another round of betting from the left. When that ends, the final card is dealt—the "River."

Now there are five cards face up on the table and two face down in each player's hand. Although seven cards are available, the aim is to make the best five-card hand.

Bluff plays a large part in this version of poker—and the betting tends to be much higher than the five-card draw, as players hang on to see if later cards help their hand.

The final round of betting starts with the player to the dealer's left, as before.

SOME OF THE ODDS FOR TEXAS HOLD'EM

1. HOLE CARD ODDS	
• Any pair	16/1
• Ace, king of different suits	110/1
• At least one ace	5.7/1
• Two cards of same suit	3.25/1

2. IMPROVING ON THE FLOP

You hold	Flop gives you	Odds against
A pair	Three of a kind	10/1
Any two	Two pairs	48.5/1
Two same suit	Flush	118/1

3. IMPROVING ON THE TURN

From	To	Odds against
Four cards of a flush	Flush	4.2/1
Three of a kind	Four of a kind	46/1
Two pairs	Full house	10.8/1
One pair	Three of a kind	22.5/1

4. IMPROVING ON THE RIVER

From	To	Odds against
Four cards of a flush	Flush	4.1/1
Three of a kind	Four of a kind	45/1
Two pairs	Full house	10.5/1
One pair	Three of a kind	22/1
Nothing	A pair	6.7/1

The last piece of advice is "Never try and fill an inside straight." If you were playing draw, say, and have 4, 5, 6, 8, and a king, you might be tempted to exchange that king in the hope of a seven—to make 4, 5, 6, 7, 8, a high hand. There are forty-seven cards you have not seen and only four of them are sevens. 47/4 is almost 12/1. Making a straight at either end is twice as likely, however.

It really is important to realize that poker is a difficult game. The golden rule is "If you can't spot the sucker at the table—it's you."

ESSENTIAL GEAR

~~✦~~

It isn't that easy these days to get hold of an old tobacco can—but they are just the right size for this sort of collection. One of the authors once took a white mouse into school, though considering what happened when he sat on it, that is not to be recommended. We think pockets are for cramming full of useful things.

1. Swiss army knife

Still the best small pocket knife. It can be carried in luggage on planes, though not in hand luggage. It is worth saving up for a high-end model, with as many blades and attachments as you can find. That said, there are good ones to be had for about $25.00. They are useful for jobs requiring a screwdriver, removing splinters, and opening bottles of beer and wine, though this may not be a prime consideration at this time.

Leather holders can also be purchased and the best ones come with a few extras, like a compass, matches, pencil, paper, and Band-Aids.

2. Compass

These are satisfying to own. Small ones can be bought from any camping or outdoor store and they last forever. You really should know where north is, wherever you are.

3. Handkerchief

There are many uses for a piece of cloth, from preventing smoke inhalation or helping with a nosebleed, to offering one to a girl when she cries. Big ones can even be made into slings. They're worth having.

4. Box of matches

It goes without saying that you must be responsible. Matches kept in a dry tin or inside a plastic bag can be very useful on a cold night when you are forced to sleep in a field. Dipping the tips in wax makes them waterproof. Scrape the wax off with a fingernail when you want to light them.

5. A Shooter

Your favorite big marble.

6. Needle and thread

Again, there are a number of useful things you can do with these, from sewing up a wound on an unconscious dog to repairing a torn shirt. Make sure the thread is strong and then it could be used for fishing.

7. Pencil and paper

If you see a crime and want to write down a car's license plate or a description, you are going to need these. Alternatively, these work for shopping lists or practically anything.

8. Small flashlight

There are ones available for key rings that are small and light. If you are ever in darkness and try-ing to read a map, a flashlight of any kind will be useful.

9. Magnifying glass

For general interest. Can also be used to start a fire.

10. Band-Aids

Just one or two, or better still, a piece of gauze from a cloth bandage roll that can be cut with pocket knife

scissors. They probably won't be used, but you never know.

11. Fish hooks

If you have strong thread and a tiny hook, you only need a stick and a worm to have a chance of catching something. Put the hook tip into a piece of cork, or you'll snag yourself on it.

FIRST AID

Accidents are going to happen. You can't spend your life worrying about them or you'd never get anything done. However, using common sense and taking a few simple precautions is well worth a little of your time. Really, everyone should have a basic knowledge of first aid. If you were injured, you'd want someone close to you who doesn't panic and knows what to do. It's not being dramatic to say a little knowledge can mean the difference between life and death.

When dealing with more than one casualty, a decision has to be made about which person to treat first. This process is called "triage." One rule of thumb is that if someone is screaming, they are clearly alive, conscious, and almost certainly in less danger than someone silent and still.

These are your priorities:
1. Restore breathing and heartbeat
2. Stop bleeding
3. Bandage wounds
4. Splint fractures
5. Treat shock

Keep in mind when dealing with blood and wounds, there is a risk of infection. Wear gloves if you have them, or put plastic bags over your hands. Avoid touching your mouth or face with bloody hands. Wash thoroughly as soon as possible. This advice is almost always ignored in high-stress situations, but it could save your life.

When you approach an injured person, make sure whatever hurt them isn't likely to hurt you—falling debris from a building site, for example. If there is an imminent danger, move the patient before treatment. Weigh the risk of spinal injury against the immediate danger. If the victim has been electrocuted and the current is still running, stand on something dry and nonconductive and use a stick to heave them away from the source.

If you do have to move them, avoid twisting motions that could cause spinal injuries to worsen. Pull by

the ankles until they are clear from the source of electricity.

ARE THEY BREATHING?

If they are breathing, turn them on their side and bend one of their legs up in support. This is the "recovery position." It helps to prevent choking caused by vomit or bleeding.

If breathing is poor, use a finger to remove any obstructions from the mouth and throat. Check that they have not swallowed their tongue and if they have, pull it back into the mouth. If breathing is blocked, put them onto their back, sit astride them, place your hands just above their navel, and thrust upward into the ribcage. If this does not work, grasp them around the chest under the armpits from behind, joining your hands in front if you can. Then grip hard, compressing their chest. This is the "Heimlich maneuver."

Once the blockage is clear, if they are still not breathing, begin artificial resuscitation.

Note that babies require special delicacy. If a baby stops breathing, support it facedown on your forearm. The pressure alone is enough in some cases, but if

not, press three or four times between the shoulder blades with the heel of your hand. If there is still no response, support the head and turn the baby face up, then use just two fingers to press down on the chest four times. Repeat this action. Finally, cover the baby's mouth and nose with your mouth and breathe into their lungs.

Is the Heart Beating?

To take the pulse at the wrist, press your fingers on the front of the wrist, just below the thumb at the lower end of the forearm. To take the pulse at the neck, turn the face to one side and press your fingers under the jaw next to the windpipe.

The normal pulse rate for the relaxed adult is 60–80 beats per minute. For a child it is 90–140 beats per minute. In high-stress situations, it can spike as high as 240, though a heart attack is very likely at that point.

Use your watch to count the beats in thirty seconds and then double it. If you cannot feel a pulse and the pupils of the eyes are much larger than normal, begin cardiac compression. (See next page.)

FIRST AID

Artificial Respiration

The first five minutes are the most crucial, but keep going for up to an hour while you wait for emergency services. Take turns if there are more than one of you.

"The Kiss of Life"

1. Lay the patient on his back.
2. Tilt the head back.
3. Hold jaw open and nostrils closed.
4. Check to see that airways are clear with a finger.
5. Place mouth over patient's mouth and blow firmly. It takes more effort than you might expect to inflate someone else's chest.

Watch for the chest to rise, and take your mouth away. Repeat this five or six times in succession. After that, get a rhythm going of one breath every five seconds. After ten or twelve, begin cardiac compression.

With a baby, put your mouth over the nose and mouth and use short gentle breaths twenty times a

minute. A baby's lungs can be damaged by treatment that is too forceful.

With an animal, such as a dog, hold the mouth closed with both hands and blow into the nose to inflate the chest. Whether you do this will of course depend on how much you love the dog. Use a strong mouthwash afterward.

CARDIAC COMPRESSION

1. First thump hard on the center of the chest and check to see if the heart has restarted.
2. Place heel of hands on the breastbone.
3. With arms straight, push down about $1\frac{1}{2}$ inches (4 cm).
4. Do this four or five times between breaths, counting out loud.

Never try compression when the heart is beating, even if it is very faint. This could stop the heart.

Check for a pulse after one minute and then at three-minute intervals. Do not give up.

As soon as a pulse is detected, stop compressions but continue mouth-to-mouth until the patient is

breathing normally, then put him into the recovery position.

Bleeding and Injury

If anything is embedded in the wound, you will need a "doughnut" bandage. Roll a piece of cloth into the shape a tube, then join the ends to make a doughnut shape. Put this around the wound before bandaging, so the bandage won't press glass or other fragments in deeper.

An adult has up to eleven pints of blood. Losing three of them will cause unconsciousness. Even one pint can cause someone to faint, which is why blood donors are asked to sit down and have a cookie and orange juice after donating.

Immediate steps must be taken to stop the flow of blood. Pressure is the key. It slows down the blood flow enough to allow the body's own repair mechanisms to start vital clotting. Apply pressure for five to fifteen minutes and don't keep checking it. Talk to the patient as you do, keeping an eye on their state of mind and alertness. If you have no dressing, make a pad of a shirt or any other cloth.

Raise the injured part above the heart to aid clotting. Squeeze the edges of a gaping wound together before applying the pad.

Soap is an antiseptic and can be used to wash a wound to avoid infection. Hot water or boiled wine will also sterilize the site, though the application will be extremely painful. In an emergency, fresh urine will also work, as it is sterile.

BREAKS

If someone fractures a bone in an accident it may be necessary to splint the damaged limb before trying to move them. This is done by placing two pieces of wood around the damaged area and securing them with rope or a belt.

A wrist or a dog's leg can be secured in a rolled-up magazine and held in place with shoelaces. Damaged arms will need to be put in a sling and secured against the body.

A sling can be formed by a large triangular bandage which folds over the arm and is secured at the neck. If it's a broken forearm, you could tie the wrist, then take the cloth around the neck and back down. A

simple loop would work, but the arm will not be secure.

BURNS

Burns destroy the skin and carry a risk of infection. Run cold water over a burn for at least ten minutes. Try not to break any blisters that form. Give the injured person lots to drink. Remove any jewelry and clothing from the burned area. Do not apply ointments to the skin. Cover with a loose bandage if you have one, or if not, a plastic bag. Put dressings between burned fingers and toes to stop them from sticking together.

SHOCK

This can occur after any serious accident and can be fatal. The symptoms are loss of color from the lips, dizziness, vomiting, cold and clammy skin, and a rapid pulse.

Reassure the patient and talk to him. If he can talk, ask him his name and then use it often. Keep

him warm and check his breathing and pulse. Lay him down and elevate his legs. Be ready to give mouth-to-mouth and cardiac compression if he falls unconscious. Hot sweet tea is useful if he is conscious and alert. Never leave a shock victim on his own, however.

Staying calm is most important for your own safety and other people's who may be relying on you. It helps to prepare. When injury occurs, the first thing you should do is take a deep breath and reach for the first-aid kit you have prepared long before. Remember the ABC of "Airway, Breathing, Compression" and check one at a time.

MEDICAL KITS

Whether this is intended for a house or emergencies will determine the contents. There isn't much point putting athlete's foot powder in an emergency kit. However, the basics are:

1. Band-Aids and scissors. Cloth bandages are the best and can be cut to any shape.
2. Antibiotic cream and an antiseptic.

3. Needle and thread. Stitching cuts is possible if the patient is unconscious. (Dogs will occasionally let you do this, though most of them struggle like maniacs.)
4. Painkillers. Ibuprofen also works as an anti-inflammatory drug, but can be dangerous to asthmatics. Aspirin is useful in cases of heart attack or a stroke, as it thins the blood. Acetaminophen is good for pain and to bring down a high temperature. Oil of cloves can be dabbed on for tooth pain.
5. Bandages. Including one large square that can be folded diagonally into a sling.
6. Gauze pads to go under the bandage and soak up blood.
7. Lip balm.
8. High-SPF sun block.
9. Tweezers and safety pins.
10. A couple of pairs of latex gloves.
11. Antihistamine pills for insect stings or allergic reactions.

DANGEROUS THINGS
I HAVE DONE

DANGEROUS THINGS I HAVE DONE

DANGEROUS THINGS I HAVE DONE

The Pocket DANGEROUS Book for Boys

THINGS TO KNOW

Conn Iggulden & Hal Iggulden

THE POCKET DANGEROUS BOOK FOR BOYS: THINGS TO KNOW

The Dangerous Book for Boys inspired a newfound passion for adventure, fun, and all things "dangerous." Now that you have read *The Pocket Dangerous Book for Boys: Things to Do*, you can look forward to its companion book, *The Pocket Dangerous Book for Boys: Things to Know*. Available in Fall 2008, it is a compendium of the authors' facts: fun and frivolous, entertaining and useful.

Impress your friends and family with your amazing knowledge of the solar system, your uncanny ability to name the past presidents of the United States, your breathtaking brilliance at unraveling codes and ciphers. *The Pocket Dangerous Book for Boys: Things to Know* will make every man and boy as knowledgable as he has always wished to be!

ISBN 978-0-06-164993-6

Coming in Fall 2008

THE DANGEROUS BOOK FOR BOYS

**The bestselling original book for every
boy from eight to eighty.**

How many other books will help you defeat someone
at poker, race your own go-cart, and identify the
best quotations from Shakespeare? *The Dangerous
Book for Boys* gives you facts and figures at your
fingertips—brush up on the solar system, learn about
famous battles, and read inspiring stories of
incredible courage and bravery. Teach your old dog
new tricks. Make a pinhole camera. Understand the
rules of soccer. There's a whole world out there: with
this book, anyone can get out and explore it.

"A delightful collection of old-fashioned mischief."
—New York Post

ISBN 978-0-06-124358-5

On Sale Now